NEW AFRICAN CINEMA

QUICK TAKES: MOVIES AND POPULAR CULTURE

Quick Takes: Movies and Popular Culture is a series offering suc-
cinct overviews and high quality writing on cutting edge themes
and issues in film studies. Authors offer both fresh perspectives
on new areas of inquiry and original takes on established topics.

SERIES EDITORS:

Gwendolyn Audrey Foster is Willa Cather Professor of English,
and she teaches film studies in the Department of English at the
University of Nebraska, Lincoln.

Wheeler Winston Dixon is the James Ryan Endowed Profes-
sor of Film Studies and Professor of English at the University of
Nebraska, Lincoln.

Ian Olney, *Zombie Cinema*
Valérie K. Orlando, *New African Cinema*
Steven Shaviro, *Digital Music Videos*
John Wills, *Disney Culture*

New African Cinema

VALÉRIE K. ORLANDO

RUTGERS UNIVERSITY PRESS

New Brunswick, Camden, and Newark, New Jersey, and London

Library of Congress Cataloging-in-Publication Data
Names: Orlando, Valérie, 1963– author.
Title: New African cinema / Valérie K. Orlando.
Other titles: Quick takes.
Description: New Brunswick, New Jersey : Rutgers
University Press, 2017. | Series: Quick takes |
Includes bibliographical references and index.
Identifiers: LCCN 2016043416| ISBN 9780813589954
(hardcover : alk. paper) | ISBN 9780813579566 (pbk. : alk. paper)
| ISBN 9780813579573 (e-book (epub)) | ISBN 9780813579580
(e-book (web pdf)) | ISBN 9780813591186 (e-book (mobi))
Subjects: LCSH: Motion pictures—Africa—History. | Motion
pictures—Social aspects—Africa. | Television programs—Africa.
Classification: LCC PN1993.5.A35 O75 2017 |
DDC 791.43096—dc23
LC record available at https://lccn.loc.gov/2016043416

A British Cataloging-in-Publication record for this book is
available from the British Library.

∞ The paper used in this publication meets the requirements of
the American National Standard for Information Sciences—
Permanence of Paper for Printed Library Materials,
ANSI Z39.48-1992.

www.rutgersuniversitypress.org

Manufactured in the United States of America

CONTENTS

CONTENTS

AUTHOR'S NOTE

This book attempts to offer readers a cogent overview of the latest trends in twenty-first-century African film production. The Quick Takes series, dedicated to short works on various aspects of cinema, requires brevity. Therefore, capturing the cinema of an entire continent in approximately one hundred pages has proved to be a daunting task. I have, thus, concentrated on the most salient issues discussed by leading scholars of contemporary African cinema. Using examples of representative films, videos, and TV soaps from the Francophone and Anglophone regions of Africa, I hope to offer readers an introduction to the diverse types of cinema currently being made on the continent this century. These different media explore some of the most important subjects of current interest in Africa. Nevertheless, the films presented here only scratch the surface of what is, today, a huge corpus of cinematic production. I apologize for oversights and for what might seem, at times, oversimplification. Equally limited is the number of filmmakers cited and discussed in this work. I regret those who were left out and emphasize that my goal

was to try to demonstrate the diverse array of work from the continent through a few representative examples. I hope that the reader will use this book as a stepping-off point to delve further into the study of African film.

NEW AFRICAN CINEMA

INTRODUCTION

This short work offers a cogent overview of the themes and techniques employed by African filmmakers making films in the 2000s. *New African Cinema* contextualizes the most recent stage in cinema development on the continent. In most regions, contemporary cinema has evolved from eras of liberation and revolution, beginning in the early 1960s. Pioneering films of this era led to the subsequent sociopolitical and social realist *engagé* (committed) cinema of the 1970s and 1980s and on to the critical commentaries of docudrama films on genocide and civil war in the 1990s. In the twenty-first century, these decades of filmmaking have infused the transnational and transcontinental cinema that African film has become today. Films of the 2000s, made on the continent as well as by African filmmakers working internationally, promote themes that are at once local and international, humanist and globally interconnected, incorporating the latest dialogues on environmentalism, social activism, and democratic processes.

While acknowledging the colonial past as part of the present of the African sociopolitical landscape, contem-

1

porary filmmakers no longer solely blame the colonizer for the social woes of their respective societies. Today, 60 percent of the population living on the continent is eighteen years or under, thus born after the revolutions of Algeria (1962), Cameroon (1959), Senegal (1960), Nigeria (1960), Morocco (1956), and even South Africa (1994). The vibrancy of youth is shaping a film industry that is actively committed to revealing the sociopolitical challenges of, and solutions for, African countries. Films from nations as diverse as South Africa, Algeria, and Senegal, reflective of equally varied film industries and ideologies, are contributing feature-length films and documentaries, as well as made-for-TV videos, to a market that has become globally interconnected and transnationally exciting.

AN AFRICAN BRAND OF "POP CULTURE" CINEMA

Film forms have evolved across the continent since the end of the 1990s with the influence of light handheld cameras and digital technologies. Younger generations inspired by Western pop cultures are making films that glean audience recognition not only at home but also abroad. It must be emphasized, though, that unlike "pop culture" in the West, African film, whether videos or "classic" feature-length films, retains a certain dedication to

and purpose for sociocultural and political messaging. This aspect diverges from Western audiences' expectations and understandings of what cinema should be and do for us as viewers. For one thing, African film—whether transmitted through TV or videos or in cinema theaters—is never made purely for entertainment. "Pop culture film," as defined in the West, most particularly in the United States, is the product of the desire of rich, First World nations' audiences to be entertained. African viewers rarely have enough disposable income to spend on moviegoing; therefore, most Hollywood films, although distributed widely across the continent, are actually seen by very few people in Africa. Africans do recognize Hollywood as influential on the cultures of the world, but access to even the few cineplexes on the continent showing Western films is the privilege of the urban and the well-off, living in large metropolitan centers such as Accra, Lagos, Casablanca, and Johannesburg.

Most American audiences live free of war zones, famine, AIDS, political corruption, and human rights violations; thus, they have the luxury of viewing film as an outlet for pure entertainment. On the contrary, as the Moroccan filmmaker Hassan Benjelloun once told me, "we don't have the luxury of making films for entertainment" (*nous n'avons pas le luxe de faire des films de luxe*). African film, for the most part, is for sociopolitical critique, and even

the most glitzy, excessive Nigerian Nollywood film has been made with social-consciousness-raising in mind. The more "pop culture" genres—contemporary *polars* (crime dramas) on Moroccan TV and South African soaps featuring rap and reggae personalities—still weave sociocultural and political messages into their scripts that draw audiences' attention to the pressing issues of the continent: poverty, teen pregnancy, domestic abuse, disease, war, and immigration, to name only a few subjects imparted on the screen. Apart from the occasional voodoo incantation or demon-possessed man or woman in Nollywood films, we won't find aliens, zombies, Terminators, or Aladdins in African cinema. What we will find are fast-paced, thought-provoking productions that highlight the most crucial, millennial issues of not only Africa but also the planet.

Therefore, in order to consider contemporary African film as a part of the pop cultures of our era, we must broaden our understanding and our definitions. Instead of asking "what can the film do for me?" in the way of entertainment, ask "what is this film telling me?" Rarely are audiences, local and international, disappointed. For example, as the forensics officer Zineb Hajjami, the femme fatale protagonist of the Moroccan *polar El kadia*, autopsies the latest homicide victim in her glistening, state-of-the-art laboratory, we need to think about

the larger feminist messages the crime series evokes for Moroccan audiences, as well as the great strides the country has made in the new century in terms of combating police corruption and supporting a more equitable civil and just society for all. These are the overarching messages of Nourredine Lakhmari's glitzy TV miniseries featuring the beautiful Hajjami, which drew audiences to their TV sets by the thousands across Morocco in 2006.

In general, the power of African television to reach audiences and change sociocultural and political behavior is not lost on filmmakers working in countries that are challenged on every possible sociopolitical and cultural level every day. Other examples of Africa's popular cinemas include South Africa's two-year-long soap *Yizo Yizo* (This is it!), which exposed the violence and unrest that lingers in postapartheid black township schools. The country's soaps-with-a-message," *Soul City* and *Khululeka*, were equally watched by millions not only for the intrigue but also for the social issues that the characters tackled week after week. Ghanaian films such as *Ama Bennyiwa*, one of the "Twi Movies" included in the category of "Kumawood films," have "a devoted following" (Yamoah 155).[1] Films made in the Kumawood genre (considered the New Wave cinema of Ghana), can be more or less placed in the category of pop culture, as the films have been able to extend "beyond the Akan speaking

[communities] of Ghana" to reach other audiences who do not speak the indigenous language (the films are all subtitled in English) (Yamoah 155). "Ghanaian pop videos," widely available on the Internet, boast themes as diverse as condemning women for using skin-whitening creams to the exploration of demon possession. These videos are popular in urban Accra among educated and laypeople alike as well as among the Ghanaian diaspora living abroad, because "the Kumawood films do generally tell the Ghanaian story. The story lines easily resonate with the audiences, compared with some of the movies in English, which have been criticized for telling stories that do not tell the Ghanaian story" (Yamoah 160).

Despite these lively and diverse forms, African filmmakers—no matter their setting, working in cinema considered either popular or classic—are confronted with a multitude of difficulties associated with the technical side of filmmaking. These adversities are coupled with the socioeconomic hurdles that are particular to the continent. Filmmakers, like the people they represent in their films, are facing nation-states that are "weaker than [they were] in the 1960s and 1970s" and that have fallen prey to international pressures to "adopt neoliberal policies, end tariffs, reduce government bureaucracies and reduce government interventions. Privatization even of water marks the newly strengthened capitalist campaigns to reduce

state functions to the minimum" (Harrow, "Towards a New African Cinema Criticism" 310). Therefore, film-makers' contemporary challenges include a plethora of problems stemming from a dearth in natural resources to economically and socioculturally determined obstacles, all of which impede the production and distribution of films and audiences' access to them. One such tangible obstacle is the lack of theaters available to moviegoers in most African countries.

At the writing of this book, there were only thirty-five remaining viable theaters in Francophone West Africa (the countries of Benin, Burkina-Faso, Côte d'Ivoire, Guinea, Mali, Mauritania, Niger, Senegal, and Togo). The few theaters that do exist predominantly show American-made Hollywood films. For many African filmmakers, the solution to the lack of cinemas lies in taking back control of distribution and screening rights that influence local markets for their films. Khady Sylla, a well-known Senegalese filmmaker, remarks that the paltry number of theaters, coupled with the importation of cheap, American films, has virtually decimated local film industries: "In African theaters only American films are shown. We need to create theaters which will be owned by the State to screen African films.... We must facilitate the work of distributors who already have theaters so that they will show [African] films at little cost" (Keita 7). In postapartheid

South Africa, there are some eight hundred screens in seventy complexes, but most films shown are imported from Europe and the United States. In 2013, South Africa released twenty-five films and imported 179 from primarily the United States (National Film and Video Foundation 6). Commenting on continental statistics reporting the deplorable distribution records for the African film industry, the filmmaker Gaston Kaboré notes, "It is easier to watch African films in Paris, New York, Berlin, London, Tokyo, or San Francisco than to see [them] in Nairobi, Dar Es Salam, Harare, Niamey, Lagos. This situation is not only one of the commercial disadvantages, it also prevents . . . mutual development between filmmakers and the public, and at the same time, it prevents the development of indigenous criticism which could be a determinant element in the development of . . . genuine African expression" (qtd. in Akashoro 10).

In addition to the public's limited access to films, as well as state agencies' minimal investment in local theaters across most of Africa, civil wars and sociopolitical strife in the 1990s have contributed to the fragmentation and even decimation of several cinema industries. Without a doubt, civil wars in countries such as Rwanda and Algeria impacted artistically and commercially these countries' industries. The Algerian civil war (enduring roughly 1992–2004) greatly impeded Algerian filmmaking, as one

journalist notes: "Algeria entered a crisis in the late 1980s ... resulting both from a reorganization of the film sector in a privatizing direction and the outbreak of civil strife in the early 1990s" (Tazi and Dwyer 9).[2] In addition, the spreading violence across the country also engendered the "disengagement of the state, the impoverishment of the population, the increase in corruption and the contestation of power by Islamist movements" (Bonner, Reif, and Tessler 14). By 2005, when an armistice was negotiated between armed Islamic fundamentalist (known as the Front Islamique du Salut (FIS) / Islamic Salvation Front) and the army of the Algerian government, "Algerian cinema [had] zero production, zero film theatres, zero distributors, zero tickets sold" (Armes, *Postcolonial* 68). In fact, "between 1997 and 2002 not a single feature film was made in Algeria. The country [ultimately] risked cinematic amnesia" (Austin 24).

In Rwanda, filmmaking not only has returned to the country following the genocide of the early 1990s but has also become a valuable tool for helping to work through the psychological trauma of the decade. In 2005, the filmmaker Eric Kabera launched the first Rwandan film festival, which he nicknamed "Hillywood." In 2001, Kabera made *100 Days*, the first film to reveal on-screen the horrors of the genocide (Mwijuke). This film was followed by many made often with international collaborations

between Rwandans, Americans, and Europeans in the
2000s. These include: *Hotel Rwanda* (Terry George,
2004), *Shooting Dogs* (Michael Caton-Jones, 2005), *Sometimes in April* (Raoul Peck, 2005), *Un Dimanche à Kigali*
(A Sunday in Kigali, Robert Favreau, 2006), *Shake Hands
with the Devil* (Roger Spottiswoode, 2007), *Munyurangabo* (Lee Isaac Chung, 2007), and *Kinyarwanda* (Alrick
Brown, 2011).

REGIONS OF AFRICAN FILMMAKING: ISSUES AND DEBATES NORTH AND SOUTH OF THE SAHARA

When considering film from the continent, we should
be thinking about the question, How do we define Africa
without blanketing it with one set of values and as one
massive geographical space? Those who work in the fields
of African history, literature, and film generally divide
Africa geographically at the Sahel,[3] thus demarcating
between North and sub-Saharan regions. These divisions are important yet have been noticeably divisive in
professional associations such as at the African Studies
Association's and the African Literatures Association's
annual conferences, where often North Africa (Morocco,
Algeria, Tunisia, Egypt, Libya, etc.) is virtually absent,
even though this region is part of the continent. Certainly lacking is a more nuanced use of the term "Africa"

when referring to the diverse geographical locations on the continent, particularly in the titles of books that seek to define issues and contexts associated with filmmaking. For example, the titles of two edited volumes place Africa under one umbrella, not indicating specifically on what region and/or cinematic characteristics they focus: *Framing Africa: Portrayals of a Continent in Contemporary Mainstream Cinema* (ed. Nigel Eltringham) and *Hollywood's Africa after 1994* (ed. Maryellen Higgins). Will it be sub-Saharan? "Black," East and/or West, South, North "Arab," Anglophone, or Francophone? The regions of the continent are diverse and very different from one another. All face very specific socioeconomic, political, and cultural hurdles, conflicts, and challenges. It is necessary to define the cultural plurality of the region being discussed. For example, the title *Framing Africa: Portrayals of a Continent in Contemporary Mainstream Cinema* is somewhat misleading, since in reality its essays focus on films that are Anglophone and geographically representative of only sub-Saharan Africa. It would be far better if scholars could avoid regarding the continent as one, huge geographical landmass; otherwise we will continue to cover the space of Africa with blanket stereotypes. Not recognizing the continent for the vast array of differences and multicultural cosmopolitanism that it contains continues the colonial mind-set of the past: that is,

describing Africa as a huge blank slate on which we write *our* Western definitions.

The most polemical issue that surfaces in discussions of African film is how best to assess what is happening on the continent, while avoiding reducing the diverse array of filmmakers to common denominators concerning how they conceptualize their craft. Geographical, linguistic, and ethnic divisions have consistently defined Africa and, thus, the films made there; this is an essential fact that needs to be noted. More often than not, authors writing on film do not propose how best to compare and contrast African films as stratified by these divisions and differences. For example, Francophone African films, north and west of the Sahara, artistically are very different from South African, Ghanaian, and Nigerian films. Films made in former British colonies on the continent have tended to be made within different structures and under different norms than films made in formerly French colonized regions. Postcolonial nation building has impacted the formation of cinema across Africa in very different ways depending on former colonial histories. Several published works take these differences into consideration. Nwachukwu Frank Ukadike's *Black African Cinema* is perhaps the best known for having first treated the divergent cinema industries in sub-Saharan Africa in one volume. Roy Armes offers an interesting, if less developed, overview

of regional differences in *African Filmmaking: North and South of the Sahara.*

Despite these volumes, when authors do decide to make distinctions, they tend to divide the continent into broad categories, either by region—North African (Arab) cinema or sub-Saharan (Black African) film—or linguistically as Anglophone or Francophone African cinema. These linguistic denominators are also fraught with misconceptions and contribute to enduring neo-colonial markers and stereotypes that also ultimately impact global film distribution. "Francophone," in particular, is problematic since most films made in former French colonies have little to no French language incorporated into their dialogue. Ties with France are more often linked through funding sources, since the former colonizer has continued to be heavily invested in films made on the continent. In France's efforts to promote *la francophonie* (a term used to denote the entire French-speaking world) in order to rival the plethora of films that are produced in Anglophone regions of Africa, the country has continued to provide heavy subvention for cinema in North and West Africa. Ukadike draws a distinct line between regional mapping and language use in dialogues used in African film, noting that the continent's multifaceted cultures and colonial pasts "draw our attention to the problem of the search for a genuine African

film language" (6). Not only languages but also skin color and ethnic affinities become nuanced and problematic when authors try to locate and articulate the different spaces of African film. In Ukadike's effort to contextualize the framework of his own study, he remarks that "the best way to start considering cinema in the sub-Saharan continent is to establish first what is accepted as black African cinema" (6). Those cinemas emerging on the continent south of the Sahara are separated "from culturally Arabic-inclined North Africa," while "areas from the western Sudan and countries on the West Coast of the Atlantic (Mauritania to Nigeria and Cameroon) to the Congo, East Africa, South-East Africa and Madagascar" all make up what he defines as "Black Africa" (6). Yet, although this region is primarily inhabited by black Africans, it is still ethnically diverse and should not be discussed through totalizing generalities.

Anjali Prabhu's *Contemporary Cinema of Africa and the Diaspora* offers one of the few recent, comprehensive overviews of film production on the continent as well as in the African diaspora (which incorporates a diverse array of countries from Haiti to Belgium). Additional volumes published in the past decade tend to discuss African film regionally and are primarily edited volumes. For example, the aforementioned *Framing Africa: Portrayals of a Continent in Contemporary Mainstream Cinema* and *Hollywood's*

Africa after 1994 use the overarching term "Africa" in their titles; however, the essays in these works primarily discuss films exploring (or made in) Anglophone Africa with scripts for the most part written in English. The settings of the films discussed in the various chapters are principally those of Black African communities, regions, and countries. Works such as Michal O'Riley's *Cinema in an Age of Terror: North Africa, Victimization, and Colonial History* and Roy Armes's *Postcolonial Images: Studies in North African Films* more specifically engage with topics relevant to films from North Africa, which includes the seven countries and territories Algeria, Egypt, Libya, Morocco, Sudan, Tunisia, and Western Sahara. More specifically, "the Maghreb" (Arabic for "West") is the geographical designation for the countries—Algeria, Morocco, and Tunisia—which in the past were all colonized by France.[4] This region's filmmakers continue to engage with sociopolitical and culturally defined issues that have their roots in this French colonial past.

Kenneth Harrow, one of the most prolific film scholars working today, has offered several very comprehensive studies of films from sub-Saharan Africa. His most recent, *Trash: African Cinema from Below*, offers readers a glimpse into the trash heaps, human waste dumps, squalor, and poverty that have often been depicted in African cinema since independence but that have rarely been the object of

critical study. Harrow notes that the sociopolitical, histor-
ical, and artistic themes that can be associated with trash,
trashiness, and "*les déchets humains*," as Senegalese Sem-
bène Ousmane's famous film *Xala* depicts them, have for
too long been discounted as critical points of study in the
cinematic oeuvre of leading filmmakers across the conti-
nent. Harrow's book seeks to fill this gap in knowledge by
presenting an innovative and untraditional way of look-
ing at African film. Volumes focusing on one country are
also of note and helpful for understanding the specifics
of national film institutions and industries. Some of these
include my own *Screening Morocco: Contemporary Film in
a Changing Society*, Guy Austin's *Algerian National Cin-
ema*, Jonathan Haynes's *Nollywood: The Creation of Nige-
rian Film Genres*, and Robert Lang's *New Tunisian Cinema*.
These works all engender certain essential questions with
reference to how we talk, contextualize, frame, and impart
cinema from Africa to viewing publics in the West.

FRANCOPHONE VERSUS ANGLOPHONE CINEMAS

The filmmaker Sembène Ousmane, considered by most
people to be the "father" of African film, was one of the
first cineastes from a former French colony to decolonize
his films of the French language when he made *Man-
dabi* (The money order, 1968). The filmmaker made two

versions of the film, one in French and then another in Wolof. *Mandabi*, in particular, marked the beginning of the West African filmmaker's desire to complete a *retour aux sources* (return to the sources) of culture and heritage after colonialism. In the late 1960s, Sembène and others realized that if film was going to be a useful tool to educate spectators, "the audience had to recognize themselves in films, to feel involved and to identify with the questions the filmmaker wants to raise" (Bartlet 21). This is exactly what *Mandabi* accomplished when Sembène presented it in his indigenous Wolof to the Senegalese in the late 1960s.

However, questions about language, that is, indigenous versus former colonial, for many filmmakers, both from North and sub-Saharan Africa, are conflicted. In some respects, French and English are viewed as "no one's property" (Bartlet 197). Immediately following Algeria's independence in 1962, the famous Algerian author Kateb Yacine noted that "le français est un butin de guerre" (French is a booty of war). Kateb wrote both in French and, later, in his native Algerian Arabic. For filmmakers, though, one of the most important questions asked after revolutions for independence was, "what to do with French?" The well-known Mauritanian filmmaker Med Hondo, commenting on using French in his films, affirmed in an interview, "It has become my language and my tool. I sweated blood to acquire it, and no one's going

to take it away from me. It wasn't a gift, it was an achieve-
ment. Even though I am a user of French, I don't feel any
calling to become an activist for the French language"
(Bartlet 197). Whereas the Ivorian filmmaker Kitia Touré
states, "We are told . . . that making a film in French means
alienating African culture from the French language.
Bullshit!" (Bartlet 197). Touré raises an interesting point
about French use in the former colonies of Africa and one
that is applicable to Maghrebi films as well. The popula-
tions of these countries are overwhelmingly urban, par-
ticularly those who go to see films, and "used to French
as an everyday language" (Bartlet 197). What to do with
the colonial language has been the conundrum for many
filmmakers, certainly when seeking international fund-
ing, distribution, and, in general, wide audience appeal,
particularly in metropolitan locations where multiple lan-
guages are spoken.

What is still true today is that if filmmakers want to
become internationally recognized, they still must pass
through European film distribution networks. Therefore,
incorporating European languages into films has proved
beneficial in some respects. The Festival panafricain du
cinéma de Ouagadougou (FESPACO), founded in 1966,
has continued to be the largest festival showcasing Afri-
can films in the world. The festival, taking place biannu-
ally in Burkina Faso's capital, also is a meeting place for

filmmakers and potential European distributors whose funding will ensure international recognition. Equally important is the Fédération panafricaine des cinéastes (FEPACI), established in 1969, which comprises a large group of filmmakers who have been very important for the advocacy of filmmaking on the continent for decades. Both organizations originally exclusively operated in French, though this has changed over the years as more filmmakers who are non-Francophone join the ranks. Additional conundrums over language include the question of how much French (or English) to add to a film to make it sellable internationally. These are enduring issues that frame the conversations around filmmaking in Africa. One thing is certain, though, many films produced in the 2000s have definitely reduced the amount of French and other Western languages in scripts.

Without a doubt, former colonial powers have shaped how film industries have developed in the postcolonial era. Ukadike notes that while Britain, Belgium, France, and Portugal "carved out and shared Africa, the cinema in the ex-colonies followed different patterns of development" depending on attitudes, technologies, and styles used in these colonial powers' national cinemas (5). For example, the films of French West and Equatorial Africa share similarities not present in the films of ex-British colonies. Moreover, these regional groupings are distinct

from the representative styles adapted by the East African countries Angola and Mozambique, both ex-Portuguese colonies whose independences came only in the mid-1970s. All three of these regions differ in their approach to and execution of narrative, methods of representation, and definition of documentary film (Ukadike 6).

Following independence in many former African colonies, Great Britain left little in the way of a film industry. The United Kingdom preferred to invest in television and radio, unlike France, which left an enduring model on which countries such as Algeria, Morocco, Tunisia, and Senegal built their national cinemas. These cinema industries later produced thirty-five-millimeter feature-length films on a regular basis. Lusophone Africa (Angola, Guinea-Bissau, and Mozambique), formerly colonized by Portugal, primarily focused its fledgling industry on documentaries and revolutionary films heavily funded directly by the state after independence (Diawara 88). During the 1970s revolutions in these countries against the Portuguese, film was used by guerrilla fighters as a tool for propaganda that furthered the revolutionaries' cause. The rebel groups—FRELIMO (Liberation Front of Mozambique), MPLA (Movement for the Liberation of Angola), and PAIGC (African Party for the Independence in Guinea and Cape Verde)—all made documentary films during the 1970s. After independence, "the

revolutionary governments of Mozambique and Angola, the most active centers for film production, supported landmark films made by pioneering filmmakers . . . [such as] Sarah Maldoror" (Andrade-Watkins 180). Not only recognized for being one of the first postcolonial films by an African woman, Maldoror's *Sambizanga* (1972) became an iconic, revolutionary work that exemplified the anticolonial struggle of the region. "Through cinema filmmakers depicted the historical, political, and social impacts of colonialism and civil war on the different populations in these countries" (Meleiro). Other film-makers such as Ruy Duarte de Carvalho and Antonio Ole produced revolutionary documentaries for Ango-lan television in the 1970s. *Sou Angolano trabalho com forca* (I am Angolan, I work with strength) "was a major eleven-part 1975 documentary series on the workforce [of Angola]" (Andrade-Watkins 186). The film critic Alessandro Meleiro explains that since the 1970s civil wars in Mozambique and Angola, war has been the pri-mary subject of films as filmmakers attempt to establish a filmmaking industry while also helping audiences to heal from the trauma of conflict:

> The analysis of the Angolans' experiences of the civil wars and the damage these conflicts have had on citizens around the country is examined in . . . Maria João Ganga's *Na cidade*

vazia (Hollow city) (2004) and Zezé Gamboa's *O herói* (The hero) (2004). . . . [Both] illustrate[] how these years of conflict disrupted the lives of thousands of Angolan civilians and . . . gradually snuffed out that country's short but distinguished filmmaking tradition. This is evident in the low number of films produced between the 1960s and early 2000s.

Countries such as Nigeria, Kenya, and Zimbabwe did not emulate national cinema models like those found in formerly French West and North Africa during Europe's colonial rule of Africa. Unlike the British and the Belgians, the French "had no policy of producing films that were especially intended for their subjects in Africa" (Diawara 22). If anything, France viewed filmmaking in the hands of Africans as potentially dangerous. In 1934, the French colonizers implemented the Laval Decree (Le Décret Laval) throughout its colonies, which stipulated that under no circumstances were African films to be made by Africans "lest the involvement of Africans in these activities become subversive or anticolonialist" (Diawara 22). The Laval Decree was denounced by African filmmakers such as Paul Vieyra and Le groupe africain du cinéma, whose members lobbied repeatedly to counter the restrictive law. The French filmmaker Jean Rouch, despite being accused of exotifying Africans and treating

them paternalistically in his documentary films of the 1950s and 1960s, nevertheless invested in local filmmaking and encouraged and mentored indigenous filmmakers in Niger and Ivory Coast. "Rouch employed his African actors as his assistants, and in the process he discovered and helped two pioneers of African cinema, Oumarou Ganda and Moustapha Alassane" (Diawara 24).

France's investment in the national film industries of its former colonies began in 1961 "with the creation in Paris of the Consortium Audiovisuel International (CAI)," whose sole purpose "was to help the newly independent African countries in the field of communications" (Diawara 24). Partial production companies were founded in Francophone African capitals, and in Paris, the CAI would provide postproduction technology (Diawara 25). In 1963, Jean-René Débrix became the director of the Bureau du cinéma, also known as the "Coopération," which added film to "France's aid to its former colonies . . . in the domain of literature, theater, music, and dance" (Diawara 25). These historic pacts made with the continent contribute to the general consensus underscored by Manthia Diawara that despite France's neocolonial role in cultivating film on the continent, countries where national film institutions were established at the time of independence led more quickly to many "films directed by Africans." Diawara emphasizes that films made in "the former

French colonies are superior, both in quality and in quantity, to those by directors in other sub-Saharan countries formerly colonized by the British." This is mainly due to the French institutional model that funds filmmakers (21). For better or worse, even long after decolonization, France has continued to fund African cinema in its former colonies. Therefore, "it [is] easier for French distributors to maintain their monopoly on the African market," but also film in these regions is much more vibrant and institutionalized as an art form than in former British colonies (Diawara 31). Investment of this type is not mirrored in Anglophone regions, thus many scholars have argued that France's omnipresence in Francophone cinema on the continent has contributed to the different, some say even neocolonial, tendencies represented in postcolonial films, as notes Ukadike in *Black African Cinema*:

Different patterns of film production within Francophone and Anglophone regions derive from the contrasting ideological pursuits of the colonial French and British governments. For example, while the French pursued the so-called assimilationist policy, British involvement with its colonies was pragmatic business. Similarly, observers point out that while the French "gave" feature film to its colonies, the British "gave" theirs documentary. This notion supports the argument that the cultural policy adopted by France

encouraged film production in the Francophone regions whereas in the Anglophone regions, where film production did not pass the economic priority test . . . the tradition of British documentary filmmaking [remained]. (109)

Certainly from the 1890s to the mid-twentieth century, film in the Maghreb played a role in visually depicting the colonial world for the *métropole* (metropolitan France). Sending camera operators and cinematographers to the most remote outposts of the French colonies, the Lumière brothers, Louis and Auguste, became the leading visual ethnographers of North Africa. The environments they filmed were exotic, representing a colonial world on the move not only in Africa but in Asia and the Middle East. Camera operators sent film stock back home to be shown in cinemas, garnering crowds whose desire to travel to colonial lands after their cinema experience became all the more acute. These early films fueled the fires of colonial desire and were thus a determining pillar of the French *mission civilisatrice* (civilizing mission) of the nineteenth century.

One of the first Algerians to write and publish a retrospective overview of French colonial film after independence, Abdelghani Megherbi, notes in *Les Algériens au miroir du cinéma colonial* (Algerians in the mirror of colonial cinema) that in 1896, when the first Lumière

productions were shown in Lyon, "les chasseurs d'image" (image hunters) were enlisted in droves for new projects throughout North Africa (13). Films made in Algeria in the early decades of the twentieth century included titles such as *Visages voilés, âmes closes* (Veiled faces, closed souls; Henry Roussel, 1921) and *Sarati le terrible* (Sarati the horrible; René Hervil, 1922), based on a novel by the French author Jean Vignaud. These films painted a cinematic picture of Algeria that "inspired numerous filmmakers, both European and American . . . by offering a *'pittoresque'* view of Algeria that was exotic and captivating" (Megherbi 77). *Sarati le terrible* was so popular that it was remade in 1937 by André Hugon from Algiers, who, although French-Algerian, shot most of the scenes in Paris. The film focuses on a colonial white man from the underclass (known as a *petit blanc*; little white man)[5] who desires his adopted daughter but whose marriage to someone else leads him to commit suicide. The tragic melodrama, writes Megherbi, revealed a "colonial universe [that was] brutal, in its virulence, its injustice, and its arbitrariness and its distain for the colonized 'Other'" (98). The most well-known of these tragic melodramas is the iconic *Pépé le Moko*, filmed in Algiers in 1937 by Julien Duvivier. The film was based on a detective novel by Henri La Barthe (O'Riley 129). Duvivier's previous film, *La bandera*, filmed in Morocco in 1935, was also immensely

successful with audiences at the time. *Pépé le Moko* is the story of a small-time bandit, played by Jean Gabin (the heartthrob of 1930s French film), who, after committing petty crimes in Marseille and serving jail time, seeks out a gangster he has met in prison. When Pépé goes to find him, he meets the mother of the gangster, who tells him that his inmate-friend has gone to Algiers. Thinking he can make money by following in the gangster's footsteps, Pépé secures false papers and goes to Algeria to seek him out. Through mishaps, Pépé is tracked by the police, lives on the lam, and becomes destitute in the streets of Algiers, before falling in love with a French female tourist who has been hired by the police to trap him. Pépé's indigenous Algerian lover, learning of the other woman, betrays him to the police instead. Refusing to surrender, the hero stabs himself (Megherbi 246–247).

Many film historians have read *Pépé le Moko* metaphorically as a harbinger of things to come. Algeria is viewed as the temptress who betrays the "benevolent" colonizer in order to seek and fulfill her own interests—that is, independence. Michael O'Riley notes that Duvivier's film serves as the basis for what would be a constant leitmotif in Maghrebi films by both *pieds-noirs* (white settlers)[6] and, later, indigenous Algerians: victimization, both the colonized's and the colonizer's (20). This "cyclical vision of colonial victimization," has influenced the themes of

films on both sides of the Mediterranean ever since independence (O'Riley 129). For the French, victimization is represented in later, nostalgic *pied-noir* films such as Brigitte Rouan's *Outremer* (1990) as loss or "haunting" by what was given up and left *là-bas* (there), in Algeria. For Algerians, victimization is still rendered through the prism of French colonial brutality, manipulation, and exploitation, which endured for 132 years. The Algerian Rachid Bouchareb's *Indigènes* (Days of glory, 2006) aptly describes this victimization, revealing the inequality of the French colonial era that reigned in Algeria, dividing the colonized and the colonizer. He retells the story of Maghrebi conscripts in the French army who were sent to France to fight against the Germans during World War II only to find that they had to fight not only "the enemy" but also French racism, in the French army, as they fought on French territory.

Despite colonial history, French institutional models, know-how, and a particular French imprint remains most prominently on the cinemas of the Maghreb. La fémis (l'École nationale supérieure des métiers de l'image et du son), formerly known as the IDHEC (Institut des hautes études cinématographiques), and l'École supérieure d'études cinématographiques (ESEC) have been the leading schools of training for Maghrebi filmmakers since independence.[7] Férid Boughedir (Tunisia), Merzak

Allouache (Algeria), and Farida Benlyazid (Morocco) have all studied film in Paris. Through these state-funded schools, France established filmmaking as a national institution, which meant that the government would always contribute funds to making films at home and abroad, including funding films in the former colonies. The subsidy model, known as *l'avance sur recettes* (advance on ticket sales), was also adopted by Maghrebi national industries in all three countries.

Most scholars agree that African cinema (here defined as "classic," thirty-five-millimeter, feature-length film) is the most dynamic in the former French colonies, "perhaps evidencing France's lead in encouraging the development of cinema in Africa" since the early years of decolonization (Ukadike 16). This is most true in the Maghreb, which has, since the 1960s, utilized its proximity to France and Europe to develop a sophisticated film industry. The region's religious and perceived Arabic ties, influenced by Egyptian and Mediterranean filmmakers, at least in the early postcolonial era, also played roles in shaping Maghrebi cinema. Ukadike claims that "religious and linguistic" roots also "reinforced the North African communion with Arab heritage" (35). While this was partially true in the 1960s, when national cinemas were very much linked to nation-state building, from early on, the film industries of these three former French colonies

evolved very differently from those in the Middle East—
thematically and linguistically. By the end of the 1960s,
Maghrebi filmmakers distanced themselves from Middle
Eastern, Arabic cinematic traditions. Unlike Egypt and
the Mashriq region (Lebanon, Syria, Jordan), Maghrebi
cineastes preferred to cultivate an original body of work
that challenged what was considered "un vieux cinéma
arabe" (an old Arab cinema; Tebib 60). In actuality,
Maghrebi cinema has always viewed itself as being partic-
ularly unique: "The role of Maghrebi cinemas is to repre-
sent a cinema profoundly innovative for the Arab World"
(Tebib 60). For example, in the 2000s, Berber-language
films make up a significant portion of the films produced
in Morocco. Films are also shot in dialectical Arabic,
which contributes to their uniqueness, since Arab dialects
in North Africa are very different from the more standard-
ized language of the Middle East.

In West Africa, whether there is a "Francophone cin-
ema" has been debated for years, particularly since 1968,
when the filmmaker Sembène Ousmane broke with
French-language films to make *Mandabi* in Wolof. Since
the late 1960s, although many filmmakers do receive fund-
ing from France, audiences are hard-pressed to find a film
made using the French language. As in all former French
colonies, France's conception of film as *le 7ème art* (the
seventh art), an art form that was essential to the cultural

richness of the nation, was transmitted to nation-states after their respective decolonizations. Early postcolonial filmmakers particularly from Senegal, such as Paul Vieyra, Safe Faye, and Sembène Ousmane, studied in Paris. Safe Faye, one of the first women filmmakers from West Africa, worked with Jean Rouch and is still active today.

Former French colonies from the outset regarded cinema in their respective countries as operating very much as French national cinema did in France. The cinema would be a socialized institution, funded almost entirely by investments from the state. Tunisia, at the outset of its new nationhood in 1956, was the most liberal and forward-thinking country of the Maghreb. Led by the modernist Habib Bourguiba, the first president of Tunisia, the government invested heavily in its film industry, creating a national cinema that was second only to Egypt's for the most films made annually in the Arab world. In 1957, Tunisia's postcolonial government founded SATPEC (Société anonyme tunisienne de production et d'expansion cinématographiques / Independent Tunisian Company for Cinema Production and Expansion) to manage the importation, distribution, and the exhibition of films (Armes, *Postcolonial* 20). With respect to Morocco, although ruled since independence in 1956 by a monarchy, immediately after the French left, King Mohamed V invested heavily in the film

industry established by the colonizer in 1947. Independent Morocco renamed its national film institution as the Centre Cinématographique du Marocain (CCM), and it has been funded by the government ever since.

The French concept of auteur-style films, developed in the 1950s during the French New Wave (Nouvelle Vague) period, notably by François Truffaut and Jean-Luc Godard, meant that films were made in a filmmaker's signature style, reflecting his or her own vision and creativity, often using the same actors, special lighting, and dialogue. Auteur filmmaking is still in vogue, certainly in France but also in Africa by filmmakers of the former French colonies. From Sembène Ousmane to Moussa Sène Absa, Merzak Allouache, and Nabil Ayouch, to name only a few, the auteur imprint on these filmmakers' films is most evident.

The African film scholars Manthia Diawara, Frank Ukadike, and Kenneth Harrow make the clear distinction between French and British investment in the film industries of their former colonies as a key factor in the development of cinema on the continent. Ukadike notes that Anglophone nations are characterized by "a long history of expediency and entrepreneurial maneuverability which makes film production activities quite different in purpose—politically and economically—from those of the francophone region" (108). Again, as stressed in

this introduction, postcolonial film development really has its roots in the colonial enterprises and structures set up by the former colonizer. Whereas France sought to pursue "assimilationist" policies in Africa, viewing the colonized as extensions of French citizenry to be cultivated and instructed in French models, the British were much more "pragmatic" (Ukadike 109). From early on, British documentary filmmaking was used to promote tourism and educational propaganda in the country's colonized regions. Television was also considered a useful means through which to promote governmental programming and education. This tendency endured after independence. In Ghana, the first postcolonial president, Kwame Nkrumah, founded the Ghana Broadcasting Corporation-Television, thus sending a message that this mode of communication would be favored in his country (Ukadike 110). Television in Kenya is also under the control of the government and used to "promote political propaganda" much more than elsewhere in Anglophone Africa (Ukadike 110).

The tendency to favor television over national film institutions in ex-British colonies has made the import of cheap westerns and action films from the Anglophone world, primarily the United States, to countries such as Nigeria, Ghana, and Kenya much more prevalent than in other regions. The primacy of television in these countries

has shaped the way film is made and viewed, as evidenced by the rise in popularity of Nollywood videos in Nigeria. The Nigerian video scene, first launched in 1992, is now a global market of phenomenal proportions. "Nollywood," as it is termed, currently makes up the third-largest film-production sphere in the world, after India and the United States. Despite its huge market, Nollywood filmmakers remark that they are looked down on by filmmakers from Francophone regions, who more generally perceive the craft of filmmaking as an art, rather than a commercial endeavor—thus again attesting to the enduring legacy of the former colonizer's view of film. The Nollywood filmmaker Bon Emeruwa underscores this fact in the documentary *This Is Nollywood* (Franco Sacchi, 2015): "Other countries have not admitted Nigerian filmmakers to their club. . . . They look down on the fact that we make our movies on video." South Africa, too, in the postapartheid era, has ushered in Joziewood—that is, films made in the cinema-oriented urban space of Johannesburg. One of the first video film companies, which bases its model on Nollywood, named itself Joziewood in an effort to distinguish the developing cinema scene of South Africa after 1994 independence. Eighty-five percent of South Africans own a television, and the bulk of the TV-consuming population lives in poor townships of color, where there

are no cineplexes. Therefore, digital media has soared in popularity in communities where people do not have the financial means to see films or the infrastructure to support theaters (Treffry-Goatley 52).

Despite the artistic rifts and geographical divides among African countries and their film industries, since 1969, filmmakers on the continent have come together for FESPACO, which, like Cannes and the Academy Awards, continues to draw international crowds, allowing some fortuitous African films to find distributors abroad. In recent years, FEPACI has also been instrumental in bringing together filmmakers from all over the continent to strategize ways to build on inter-African filmmaking and distribution as well as to negotiate with international entities.[8]

DEFINING THE PARAMETERS OF
TWENTY-FIRST-CENTURY FILM

In order to appreciate what "new" African cinema is in the twenty-first century, a solid understanding of the "making of" this continent's various film institutions is warranted. Therefore, this book is divided into two chapters. Chapter 1, "From Revolution to the Coming of Age of African Cinema, 1960s–1990," offers a brief historical

overview of the development of African cinema since the early 1960s, which saw the dawn of most postcolonial nations (some exceptions are Angola [1974], Zimbabwe [1980], and South Africa [1994]). Without question, early political leaders of newly decolonized nations recognized both the utility and the danger that cinema offered. On the one hand, film could be useful as a propaganda tool to promote the ideology of the new state. Yet, on the other, as social critics, filmmakers who were increasingly disappointed by the unfulfilled promises made during revolutions against colonial rule questioned the ideologies of postcolonial governments. *Cinéma engagé* (socially critical cinema) has characterized the thematic choices of postcolonial cinema, as filmmakers critique the sociocultural and political realities of their independent nations. Cineastes from early on became anathema to African nations' ruling elites, who, by the early 1970s, had established autocratic dictatorships across the continent. African film as a social realist text, engaged and thought provoking, has framed the themes of filmmakers' films for decades. Even the most glitzy and action-packed twenty-first-century Nigerian Nollywood videos such as *Blood Sister* (2003), *419 Connection: Deadly Rose* (2000), and *The Battle of Love* (2000), among a plethora of others, evoke sociopolitical and cultural messages that resonate with viewers (Haynes 147). Critical, social engagement is

perhaps the most obvious distinguishing feature that the films of the continent share.

Chapter 2, "New Awakenings and New Realities of the Twenty-First Century in African Film," identifies several major aspects of new African Cinema of the twenty-first century in an effort to contextualize how the overall body of cinematic works produced in the new millennium is marking a definitive rupture with past tropes and themes in order to accommodate the contemporary sociocultural and political landscapes of the continent. Some of the parameters discussed in this section include (1) how African cinema engages with enduring Western stereotypes of the continent; (2) how contemporary films have become more mainstream (known as *cinéma populaire* in French) in the sense that there is less and less a division between high and low art, making street and slam filmmaking[9] more the norm than the exception; (3) how African filmmakers have been influenced by African authors' transnational writing, embracing certain universal, humanist tropes that have resonance both on and off the continent; and (4) how filmmakers evoke an equal dedication to both local and global issues that affect communities in Africa as well as elsewhere across the globe. Films of the twenty-first century, unlike in the past (when more nativist movements such as Negritude were favored), promote balance between the local and global influences that are

shaping the Afropolitan-infused views of filmmakers today. These films are conceptualized through a cosmopolitan, transnational, and transglobal interpretation of the world that engages with local communities as well as those beyond Africa's shores.

1

FROM REVOLUTION TO THE COMING OF AGE OF AFRICAN CINEMA, 1960s-1990s

Africa's decolonizing moments all played out in very different ways across the continent. From the late 1950s (Ghana) to the early 1990s (South Africa), postindependence has meant a variety of challenges, while presenting a multitude of issues as diverse as the continent itself. In order to understand African film history and what the cinema of the continent is today, we must first understand the overall dynamics, issues, and contexts that have shaped it. As mentioned in the introduction, African filmmaking is constantly infused by the geographical, linguistic, and cultural parameters that contribute to it. The most effective way to understand the trajectory of African film since the early 1960s is to review chronologically the various trends and influences that have shaped it up to the present. Most specifically, African filmmaking has transited

from reflecting Third Cinema ideology, popular during third-world movements in the late 1960s–early 1970s, through social realist frameworks favored by filmmakers working in the 1970s and 1880s, to Afrocentric philosophical agendas promoted in the 1990s, to finally evoking the transnational and global themes of the twenty-first Afropolitan century we see today.

THIRD CINEMA IDEOLOGY

An overarching influence that has dominated most African filmmaking, certainly in the 1960s–1970s, is Third Cinema ideology, which emerged in the early 1970s from evolving transnational third-world movements across the globe. "Third Cinema," emanating from popular liberation movements in Latin America in the late 1960s–early 1970s, was first coined as a term by the Argentine filmmakers Fernando Solanas and Octavio Getino within their group, Grupo Cine Liberación (Cinema Liberation Group). In 1969, they published the manifesto *Hacia un tercer cine* (Toward a third cinema), which outlined how revolutionary cinema would work to counter neocolonialism, capitalist (Western) systems, and Hollywood models, which held that cinema was merely for entertainment and to make money (Pines and Willeman). Third Cinema sociopolitical ideology, used to critique

films from Latin America, was then adopted by the Ethiopian scholar and long-time professor of film at UCLA Teshome Gabriel to extend to the cinemas of the postcolonial, developing world, primarily in Africa. In his 1982 work *Third Cinema in the Third World: The Aesthetics of Liberation*, Gabriel underscores that Third Cinema is "a cinema that is committed to a direct and aggressive opposition to oppression. Its purpose will be validated only if it integrates its objectives with the aspirations, values, struggles, and social needs of the oppressed classes" (15). It is a cinema that tells audiences that in order for "the struggle of Third World countries to be successful, it is essential that the people clearly identify the enemy(ies) and see, first, that it *is* the ruling classes of the imperialist countries who oppress the Third World, rather than all whites or all Europeans and Americans" (15). Thus, for Gabriel, the sociopolitical film of the third world was fighting against not racism per se but rather the inequality that had already become visible between the haves and the have-nots in the postcolonial world.

In a later essay, "Towards a Critical Theory of Third World Films" (1989), Gabriel lays out how the revolutionary, decolonizing ideology promoted by Frantz Fanon (a leading revolutionary thinker for the decolonization of Africa in the late 1950s–early 1960s) could evolve to form a critical theory for emerging cinemas in the postcolonial

context. Whereas Getino and Solanas mention Fanon as contributing ideas of national culture, explaining that this culture in the postcolonial era would rely on writers, artists, and filmmakers to structure it, Gabriel worked deeper, looking into Fanonian praxis to explain the paths taken by revolutionary African filmmakers in the first decades of independence. Drawing on Fanon's prescription for the role of the African writer in the making of postcolonial culture, as outlined in his famous work *The Wretched of the Earth* (1961), Gabriel, like Fanon, notes that there are three phases of engagement through which the cultural producer travels in order to finally find his or her place as a critical player in the formation of postcolonial culture:

From pre-colonial times to the present, the struggle for freedom from oppression has been waged by the Third World masses, who in their maintenance of a deep cultural identity have made history come alive. Just as they have moved aggressively towards independence, so has the evolution of Third World film culture followed a path from "domination" to "liberation." This genealogy of Third World film culture moves from the First Phase in which foreign images are impressed in an alienating fashion on the audience, to the Second and Third Phases in which recognition of "consciousness of oneself" serves as the

essential antecedent for national and, more significantly, international consciousness. There are, therefore, three phases in this methodological device. ("Towards" 31)

Like Fanon's prescriptions for sociopolitically committed authors, for Gabriel, the filmmaker develops his or her critical thinking as a social activist through the three phases that Fanon outlines in *The Wretched of the Earth*. First, the cineaste makes films that mimic the Hollywood tradition; second, he enters a phase in which he "remembers who he is" by working in nation-building paradigms to make cinema an art form for the people. For example, in Algeria in the 1960s, this phase was known as *le cinéma moudjahid* (cinema of the mujahidin, the rebel freedom fighters during the Algerian revolution);[1] in Senegal and Mozambique, films were labeled *engagé*, or the cinema of the socially committed. These countries' films promoted themes that glorified "the return . . . to the Third World's source of strength, i.e. culture and history. The predominance of filmic themes such as the clash between rural and urban life, traditional versus modern value systems, folklore and mythology," characterized the themes of this phase (Gabriel, "Towards" 32).

The last and most defining phase is the "combative," in which filmmakers make films for the people, insisting "on viewing film in its ideological ramifications" as "an

ideological tool." In this last stage, film becomes danger-ous for nation-states' governments, as filmmakers become more critical of them. Ousmane Sembène's famous *Ceddo* (1977) is one such film (Gabriel, "Towards" 34). *Ceddo* tells the tale of a *ceddo* (villager) who goes against a king in an African village who has let Islam infiltrate, usurp-ing traditional cultural practices. In order to combat the Islamic conversion taking place, the *ceddo* kidnaps the king's daughter, vowing not to return her until the king stops the wave of Islamicization. The king dies, and the Imam takes charge, thus "launching the conversion drive forcefully and brutally and in the end rescuing the prin-cess, whom he intends to marry. The Imam is eventually slain by the princess" (Ukadike 183). Ukadike notes that *Ceddo* is "an iconoclastic film" because it is staunchly antireligious, "focusing mainly on the Islamic impact and particularly questioning the subjugation entrenched in its ideology and the acceptance of this ideology by Africans to the extent of rendering traditional cultures impotent" (183).

The Marxist-influenced Sembène remained steadfast in his belief that imported religions from elsewhere in the world would forever hold Africa hostage and deny Africans access to their own belief and value systems. These foreign religions were essentially different modes of colonization that kept Africans from embracing the

true sense of their being. Although an allegory, the film's blatant political messages countered the unifying goals that the Christian president, Léopold S. Senghor, had for his country. He banned the film for eight years, fearing that if released, it would cause divisions across Senegal. Avoiding the religious questions and debates that the film raised, the president "officially" condemned the film "because Mr. Sembène insists on spelling 'ceddo' with two d's while the Senegalese Government insists it be spelled with one" (Canby). *Ceddo* symbolizes the contentious debates that filmmakers presented to their respective governments from the 1970s forward. As a staunch sociopolitical critic, constantly challenging Senegalese political leadership, as well as the customs and traditions that impeded the people from embracing modernity, Sembène Ousmane led his Marxist-secular charge up to the time of his death in 2007.

REVOLUTIONARY CINEMA AS PROPAGANDA

Like West Africa, the cinema of the Maghreb has, in the years since independence, also closely reflected the changing tides of Tunisia's, Algeria's, and Morocco's political oceans. Although, since the mid-1960s and the outset of independence, all three national cinemas were conceived of in more or less the same terms, they have,

nevertheless, been molded in very different ways by the sociocultural and political dynamics, events, and challenges taking place in each nation. As mentioned in the introduction, all three countries founded their national cinemas on the French institutional model (which meant setting up agencies funded by the state, usually overseen by a ministry of culture) that would provide subsidies to filmmakers to make their films. This model was used by all three nations from the mid-1960s forward to hone a "new sense of national identity [by] seeking new forms of expression" through film (Armes, *Postcolonial* 8). Film was a way to further the ideologies of each nation's government while also giving to the world for the first time the expression of "a reality as seen from a specifically Algerian, Moroccan [and] Tunisian perspective" (Armes, *Postcolonial* 8).

What is interesting is how each model, conceptualized similarly at the founding of these postcolonial states, was later challenged at various moments in history by filmmakers operating in very different ways. The French model, prescribing that film perform as an art form in society, continues to influence the national cinemas of Morocco, Algeria, and Tunisia. Despite taking to heart Fanon's plea to cultural producers (in film, the arts, and literature) to help express the culture of new nations, national film industries still rely on a colonial institutional

model. Nevertheless, these institutional models were instrumental in the early 1960s in helping to define the agendas of new nations, which used them to inspire their peoples to think about the future. Postcolonial filmmakers used their cameras to seek to live up to Fanon's challenge. The formerly colonized "must get away from white culture. He must seek his culture elsewhere," and the "style" of the filmmaker, as for the writer, "is harsh, ... full of images, for the image is the drawbridge which allows unconscious energies to be scattered on the surrounding meadows.... This style ... has nothing racial about it.... It expresses above all a hand-to-hand struggle and it reveals the need that man has to liberate himself from a part of his being which already contained the seeds of decay" (Fanon 220).

The use of films as a means to document liberation is best exemplified by Algeria in the early 1960s. "Algerian cinema was born out of the war of independence and served that war," notes Guy Austin in his book *Algerian National Cinema* (20). Algerian cinema was useful for capturing the horrors of the war of liberation as well as mythologizing the FLN's (Front de libération nationale / National Liberation Front) struggle to free the country from French colonial rule and ultimately bring to fruition the Algerian nation. From the first years after independence in 1962, the "'*cinéma moudjahid*' or 'freedom

fighter cinema' of the 1960s and 1970s was central to post-independence cultural policy" (Austin 20). Over the past five decades, we can say that Algerian cinema has always celebrated "the new nation-state but also interrogates the discontents of the new Algeria" (Austin 20). Elsewhere, across the Maghreb, this has been true in varying degrees, depending on the politics of governing authorities after independence. Early films such as *Rih al-awras* (Wind from the Aurès; Mohamed L. Hamina, Algeria, 1966), *Al-fajr* (The dawn; Omar Khlifi, Tunisia, 1966), and *Inticar al-hayat* (Conquer to live; Mohamed Tazi and Ahmed Mesnaoui, Morocco, 1968) all imparted to audiences the winds of change that filmmakers hoped would come with independence in order to build strong and powerful postcolonial states (Armes, *Postcolonial* 213).

Films also were used as a means for forgetting colonial brutality and for moving forward in the early days of postcolonial nation building. Many filmmakers proposed themes to help work through the trauma of the bloody battles of decolonization, particularly in Algeria: "The function of Algerian films in the liberation struggle [in the 1960s] seems closer to the narrativisation of trauma as a means of remembering to forget, hence a 'working through,' an articulation of national identity that seeks to commemorate suffering but thereby to move onwards

and to build new power structures (the FLN state), rather than as a traumatized perpetual present" (Austin 35).

Moroccan cinema, though, was conceptualized in a different manner from its Algerian neighbor's industry. Although ruled since independence in 1956 by a monarchy, the king of Morocco invested heavily in a national film institute that had already been established by the French in 1947. The Centre Cinématographique du Marocain (CCM) took form in 1957. Since this date, the state has subsidized films for over fifty years. King Mohamed V, the first ruler of independent Morocco, regarded film as a means to document social development in the country immediately following independence. For the first few decades, most films made in the country were documentaries. The CCM sent filmmakers abroad to France, Russia, and Italy to learn the trade. At the same time at home, the CCM established a studio, lab, film stock, and trained personnel in Rabat, Casablanca, and Marrakesh. Filmmakers, however, for many years after independence, concentrated only on promoting themes highlighting regional and economic development issues that could be filmed as documentaries (Carter 67). Mohamed V's death in 1963 and the enthronement of his son, King Hassan II, marked a new chapter in the development of Moroccan cinema. During the Lead Years (*Les années de plomb*, 1963–1999), which characterized repressive King Hassan II's

rule, Moroccan film was viewed as a form of media particularly dangerous to the monarchy.[2] It was monitored heavily, and filmmakers felt hindered by censored scenes, curtailing their ability to probe the sociopolitical topics of the era. Up to the end of the Lead Years (1999, with the death of Hassan II), Moroccan films metaphorically or symbolically proposed ideas criticizing social woes, but filmmakers rarely dared to be overtly critical.

Despite widespread repression of the industry by the monarchy of Hassan II, films of the 1980s, such as Ahmed Kacem Akdi's *Ce que les vents ont emporté* (Talk is easy, 1984), Mohammed Aboulouakar's *Hadda* (1984), and Mohammed Derkaoui's *Titre provisoire* (Provisionally titled, 1985), demonstrate the Third Cinema movement's influence on themes and styles. By the mid-1990s, the social realist, politically committed films of West Africa had strongly influenced Moroccan filmmakers. Since the late 1990s, Moroccan cinema has developed into one of the most vibrant industries on the continent. Films such as Hakim Noury's *Voleur de rêves* (Thief of dreams, 1995), Fatima Jebli Ouazzani's *Dans la maison de mon père* (In my father's house, 1997), and Nabil Ayouch's *Mektoub* (Destiny, 1997) all document and bear witness to the sociocultural and political changing landscapes of Morocco at the end of Hassan II's oppressive rule (Orlando, *Screening* 9–10). These films were openly critical of the political

corruption, poverty, illiteracy, and a host of other social ills that continue, even today, to persist in Morocco.

From the outset of the postcolonial era and up to the recent Arab Spring of 2011, Tunisia's industry has been one of the most engaging in the Arab world. Originally led by the modernist and first postcolonial president, Habib Bourguiba, the Tunisian government invested heavily in its film industry, creating a national cinema that was second only to Egypt's for the most films per year made in the MENA (Middle East and North Africa) region. In spite of Tunisia's reputation as the only democracy in the Arab world, like other countries in Africa, Bourguiba's forward-thinking government, forged in 1956, was short-lived. In 1987, the first president of postcolonial Tunisia was deposed in a bloodless coup led by Zine El Abidine Ben Ali (who declared himself president for life, although he did allow elections). Tunisian films such as the well-known Ferid Boughedir's *The Picnic* (1972), Nouri Bouzid's *Rih essed* (Man of ashes, 1986), Mohamed Zran's *Essaïda* (1996), and later, Nadia El Fani's *Bedwin Hacker* (2002) served as "allegories of resistance" challenging "civil and human rights [abuse and] things that had not improved in Tunisia since the colonial era or the darkest days of Bourguiba's presidency" (Lang 3). Filmmakers continued to condemn the subsequent tyranny of Ben Ali up to the Arab Spring in 2011, which deposed him.

AFRICAN SOCIAL REALIST CINEMA OF THE 1970s

Frank Ukadike rightly claims that since the "beginning, the major concern of African filmmakers has been to provide a more realistic image of Africa as opposed to the distorted artistic and ideological expressions" the West projected on the continent, during and after the colonial era (3). This is particularly a sentiment felt with regard to Black Africa. African social realism, cultivated in the 1970s in didactic films such as Sembène Ousmane's *Xala* (1975), is concerned "with the role film can play in building African society, . . . especially in portraying African cultures" (Ukadike 3). Many of the obstacles confronting filmmakers in the 1970s were considered the result of the European colonial legacy, the fragmentation of African indigenous societies, postcolonial corruption, poverty, and Western coercion and manipulation of African economies (what some people condemn still today as economic neocolonialism). It is for these reasons that from the early 1970s forward, African filmmaking developed into not only an art form but a social lens through which filmmakers became visual spokespeople. Their primary duty—and here we can think of this era within the framework of the third phase of Gabriel's Third Cinema ideology—was to foster the enlightenment of their own people. African filmmakers, particularly Sembène

Ousmane and Moussa Sene Absa from Senegal, and Gaston Kaboré from Burkina Faso, called attention to the fact that African films must always "question contemporary events" (Ukadike 129).

Social realist frameworks for the first thirty years or so of the postcolonial era, although overtly didactic, achieved their aims because they were able to "blend comedy and melodrama, ridicul[e] eccentric paternal figures and emphasiz[e] the tragic clash between tradition and modernity." They were also very effective at exposing "the contradiction between the values of the city and those of the village" and were able to "denounce acculturation," all the while attempting "to raise the consciousness" of the characters in the films as well as that of the audience (Diawara 119). Manthia Diawara specifically defines African social realist cinema as promoting scripts whose "heroes are women, children, and other marginalized groups that are pushed into the shadows by the elites of tradition and modernity" (141). Films of the 1970s draw "from existing popular forms such as song and dance, the oral tradition, . . . and popular theater (Yoruba theater in Nigeria, and the Koteba in Mali and Ivory Coast)" (Diawara 141). Particularly, the cinema of sub-Saharan Africa incorporates popular music by "music stars" such as "Salif Keita, Papa Wemba, and Alpha Blondy" (Diawara 141).

Sembène's films from the late 1960s–1970s, *Mandabi* (The money order, 1968) and *Xala* (The curse, 1975), as well as Malian Souleymane Cissé's *Baara* (1978) and *Finye* (1982), are iconic social realist films. Additional films made in the genre include Moustapha Alassane's *Femmes, villa, voiture, argent* (Women, villa, car, money, 1972), "which parodies the postcolonial bourgeoisie"; Johnson Traoré's *Njangaan* (1974), dealing "with the role of Islam and Koranic schools in contemporary Africa"; and Daniel Kamwa's *Pousse pousse* (Push, push, 1975), "about the problem of dowry" (Diawara 142). Essentially, social realist frameworks dominated films from West Africa and, to some extent, the Maghreb from the 1970s through the 1980s and 1990s. All the films made during these decades "appeal to the African masses because they can identify with the characters in them" (Diawara 142).

1980s–1990s: FROM WINDS OF CHANGE AND CIVIL WARS TO THE AFROCENTRICITY OF NEW CINEMAS

By 1980, twenty years after independence movements bore the fruits of revolutionary causes in the majority of African countries, postcolonial governments were failing to meet the needs of their peoples. Failed ideologies and failed nation-building influenced the already social realist, critical-themed films of the era. Gaston Kaboré's

Wend Kuuni (1982) and *Zan Boko* (1988) and Ben Diogaye Bèye's *Un homme des femmes* (A man of women, 1983) and *Moytuleen* (1996) were just some works that outlined the most salient topics of the continent. Rising oil prices and tensions in the Middle East, spilling over to North Africa and Nigeria, and civil wars and genocides in Algeria, Sierra Leone, Ivory Coast, Chad, and Rwanda in the late 1980s and early 1990s decimated film industries as well as the governments running them. While the situation was bleak in many respects, one bright hope was South Africa, newly liberated from apartheid in 1994. The 1990s also rung in the advent of new digital technologies—from videos and VCRs to handheld cameras and DVDs—which drastically changed who was able to make films and how.

Filmmakers continued to use their social realist themes, operating as visual spokespeople for their people, as they documented the realities of their countries. West African filmmakers drew on certain central ideologies promoted in the early 1980s to construct the paradigms of their films. Influenced by Africanist scholars, their filmic texts "introduced fundamental referential changes in the African community," which reflected the cumulative theories, ideologies, and philosophies of almost half a century of revolutionary thought (Mazama 3). From Fanon to Aimé Césaire, Senghor to Cheik Anta Diop and Molefi Asante, Africanist revolutionary philosophy

became a "formidable Pan-African development," introducing an "African gnosis," as promoted in works such as *The Invention of Africa: Gnosis, Philosophy, and the Order of Knowledge* (1988) by V. Y. Mudimbé (Mazama 3). The tenets of Afrocentric philosophical thought supported an "epistemological centeredness" that Molefi Asante proclaimed provides "a frame of reference wherein phenomena are viewed from the perspective of the African person.... As an intellectual theory, Afrocentricity is the study of the ideas and events from the standpoint of Africans as the key players rather than victims.... It is Africa asserting itself intellectually and psychologically, breaking the bonds of Western domination [of] the mind as an analogue for breaking those bonds in every other field" (Mazama 5).

The Afrocentric idea asserted the primacy of the African experience and aimed to represent a perspective that placed emphasis on the essentiality of community, tradition, spirituality, and respect for the natural environment, as well as selfhood and "the unity of being" (Mazama 9). Afrocentricity promoted a new form of continental African nationalism that allowed for bonds to be forged across geographical frontiers within the continent. In the era of a nascent Internet, such ideological probing was further actualized. It also privileged messages of self-reliance and ideologically supported filmmakers in their mission to

show to audiences that Africa was responsible first and foremost for the sociopolitical transitions as well as the civil wars and genocides taking place on the continent. Films such as Sembène Ousmane's *Guelwaar* (The noble one, 1994), again like *Ceddo*, analyzed the theme of violence between warring religions in Senegal, sending the message that it is up to the Senegalese people to confront their ineffectual government in order to devise peaceful solutions. Merzak Allouache's *Bab el-Oued City* (1994) condemns the growing violence and the escalation of tensions between religious fanatics of the FIS (Front islamique du salut / Islamic Salvation Front) and Algeria's leaders (headed by President Chadli Benjedid in the early 1990s), which eventually led to civil war and the massacre of almost three hundred thousand people before its final end in the early 2000s.[3]

The aforementioned films and many others were mirrors held up to the faces of Africans that, as Sembène Ousmane notes, compelled the filmmaker to consider him- or herself as an artist who made sure that the *conscience du groupe* (group consciousness) is at the forefront of his or her film. "Les dirigeants politiques ont peur de nous" (political leaders are afraid of us), Sembène noted at a National Endowment for the Humanities (NEH) seminar held in Dakar in 2005.[4] Although filmmakers as activists were not new in the 1990s, as internal challenges

confronted the continent, the role of the cineaste became increasingly important.

As Algeria and Rwanda slipped into bloody civil wars in the early 1990s, South Africa was liberated in 1994 of its repressive apartheid, white-ruled government. Whereas a very white-run cinema industry from the early twentieth century up through the 1980s had been used as a tool to reiterate the "idea of white superiority, and therefore, the legitimacy of white people to rule over black people," film in the early 1990s became a means through which to "establish a democratic society" (Modisane, *South Africa's* 5). A more inclusive cinema was born in 1995 with the draft of "the white paper regarding a post-apartheid film industry" that in its final version in 1996 outlined the structure of the National Film and Video Foundation Bill, ultimately ratified by South African Parliament in 1997 (Botha 16). Yet the establishment of a postapartheid cinema has its roots in preindependence mass movements, which rallied students and workers to oppose the status quo in the 1970s and 1980s. Overall, "the history of [film-making and] film distribution in South Africa has sadly been one of racism and segregation" (Botha 13).

However, despite threats of censorship during the state of emergency in the 1980s, several monumental films were made that challenged white supremacy and ultimately helped form the antiapartheid movement that

led to the overthrow of white rule. Feature films such as *Mapantsula* (The hustler, 1988), *The Stick* (1988), *Jobman* (1989), and *On the Wire* (1990) "together with numerous community and resistance videos became vital instruments in the anti-apartheid struggle" (Botha 14). Both *Mapantsula* and *The Stick* were banned until the mid-1990s, and "*Jobman* has still not been commercially released in South Africa." The venues for showing these films were also covert—"community halls, churches in the townships, selected progressive film festivals, and even private homes"—thus making them even more noteworthy as tools for liberation (Botha 14). In the 1990s, "co-productions led to six local films receiving international attention": Darrell Roodt's *Sarafina!* (1992) and *Cry, the Beloved Country* (1995), Elaine Proctor's *Friends* (1993), Les Blair's *Jump the Gun* (1997), Shyam Benegal's *The Making of the Mahatma* (1996), and Katinka Heyns's *Paljas* (1998). These cinematic works helped launch the postapartheid national film industry. South African film in the postapartheid 1990s played "a vital role in the forging of social cohesion and the process of democratization and development that so urgently need[ed] to take place" as "new voices and a diversification of the industry" were being cultivated (Botha 15–16).

Without a doubt, one of the most interesting developments of African filmmaking in the 1990s has been the

phenomenon of Nollywood cinema in Nigeria. A filmic form that came about very rapidly thanks to new developments in video technology, handheld cameras, and computer editing software, Nigerian videos have made their mark on the continent and across the globe. As mentioned in the introduction, Nollywood is now responsible for the third-largest cinema industry in the world. In 2002, the term "Nollywood" met with opposition because Nigerians felt it was an attempt to characterize their cinema as a mere copy of Hollywood. However, today, most view the industry as one that "expresses the general Nigerian desire for a mass entertainment industry that can take its rightful place on the world stage" (Haynes, "Nollywood in Lagos" 132).

The now-iconic film that "opened the markets" and founded the industry was Kenneth Nnebue's 1992 film *Living in Bondage 1*. Reported to have been made for a few hundred dollars, the film established what is today a multibillion-dollar industry (Haynes, "Nollywood in Lagos" 134). Nollywood film not only represents an art form that emerged through the innovations and popularization of cheap technology but also is the product of the socioeconomic and political failures of the postcolonial Nigerian government, a government that was, and still is, doing little to guarantee security to the Nigerian people. The dangerous sociopolitical climate necessitated

that films be viewed in private, home spaces due to the "horrendous crime rates and general breakdown of public order in the 1990s" (Haynes, "Nollywood in Lagos" 136). In the 1990s, going out to theaters at night was simply too dangerous due to social unrest and lack of urban infrastructure. "The nation seemed to be in a death spiral under the malign auspices of the self-styled 'evil genius' General Ibrahim Babangida" (Haynes, *Nollywood* xviii).

Added to the impact of Nigeria's sociopolitical stresses on moviegoing, with regard to concrete structures, the few multiplex cinemas in the country showed only American films and usually were too expensive for the average Nigerian, who earns less than one dollar a day. These influences on the industry, as well as the fact that Nigerians are a TV-watching culture much more than a cinema-going people, readily led to audiences being able to more easily identify with the TV soap-opera style of the Nollywood film. "Nigerian films were born of television, not cinema, in terms of their personnel (many of whom came from television soap operas), aesthetics, and video technology" (Haynes, "Nollywood in Lagos" 139).

WOMEN FILMMAKERS ON THE CONTINENT: 1970s-1990s

Although African women have been making films since the early twentieth century,[5] their numbers have

significantly increased in the postcolonial era since the early 1970s. Some of the most thought-provoking films of the 1970s made by women include Sarah Maldoror's *Sambizanga* (1972), about the 1961–1974 war in Angola, and the Algerian author and filmmaker Assia Djebar's 1978 *La nouba des femmes de Mont Chenoua* (The circle of women of Mount Chenoua), which took two years to make. Djebar's film traces the forgotten voices of women who participated in the struggle for independence in the rural mountain communities of Algeria. Fragmented by numerous stories told from different perspectives, the film often leaves audiences perplexed and confused. Its nebulous female accounts mirror the sociopolitical confusion of the nascent postcolonial Algerian nation. These women's stories offer no "unifying theme" but rather expose a "universe that . . . invites us to contemplate . . . a world in progress, in gestation. . . . This universe is not a totality that preexists the elements that constitute it; rather, it is an apparently chance juxtaposition or dissemination of dispersed fragments (of [hi]stories and events) in search of a unity to come (or to be created)" (Bensmaïa 84). Djebar's 1982 made-for-television film *La Zerda, ou les chants de l'oubli* (The Zerda, or the songs of forgetting) is a sixty-minute documentary that is highly avant-garde and experimental. The film melds colonial images and film footage from the early twentieth

century as Algerian narrators narrate the scenes from the perspective of the colonized. Women again are highlighted as Djebar seeks to capture their presence in a documented colonial and postcolonial history that effaced them.

The Senegalese Safi Faye is perhaps one of the most well-known West African female filmmakers, having first been recognized for her films in the 1970s. While still a film student in Paris, she made *La passante* (The passerby, 1972), a short, documentary-style, sixteen-minute film. Subsequently, working in ethnology at the Sorbonne in Paris, she made her first feature-length docudrama, *Kaddu Beykat* (1975), and *Fad'jal* (1979).[6] Films made by women directors, particularly in Senegal, are unique in their themes and scope yet act as visual, social realist texts. Although women filmmakers share with men in the desire to make artistic films, more than their male counterparts, they seek "to bear witness, give a voice to the voiceless, take stock of their own communities, their battles, and the aspirations they share for their culture" (Lequeret 11). Women directors also tend to make more documentaries than feature-length films; they feel that the documentary more readily achieves their thematic goals of studying the paradigms of marriage and certain patriarchal African traditions that burden women as they face modernity. Documentary films such as Maldoror's

Sambizanga and Djebar's *La nouba des femmes de Mount Chenoua* reveal what the sociologist Filomina Chioma Steady suggests is an "African feminism . . . [that] operates within a global political economy in which sexism cannot be isolated from the larger political and economic processes responsible for the exploitation and oppression of both men and women. The result is a kind of feminism that is transformative in human and social terms, rather than in personal, individualistic and sexist terms" (58).

West Africa through Women's Lenses

Khady Sylla and Fatou Kandé Senghor, two leading Senegalese women cineastes, have contributed significantly to the advancement of feminine filmmaking and promote a *womanist* agenda that is rooted in Afrocentrist philosophy.[7] Afrocentrist womanists define feminism and their roles and places in their respective societies on their own terms, irrespective of Western feminist paradigms. The heroines featured in African films by the earlier, groundbreaking women filmmakers Safi Faye and Togolese Anne-Laure Folly reflect a "transformation of consciousness" that depicts African women as "genuinely free to forge new combinations of personality traits . . . without the need . . . to imitate the model of the European" or to "dwell on traditional mores and customs that have hindered their active agency in contemporary African

societies" (Lazreg 322). This cinematographic transformation of consciousness also posits a new form of global *African womanism* that encourages women to recognize that their "reality has been inscribed from the West or by men" and must be reconfigured (Lazreg 322).

"African womanism," a term encompassing issues pertinent not only to African women but also to their sisters of color throughout the African diaspora, promotes the interests of women in their own societies through the sociocultural and political arenas implicit within them. African womanists maintain that their particular issues extend boundaries of discourse beyond gender-specific debates to encompass the many influences on, and conundrums within, African women's daily lives. The scholar Clenora Hudson-Weems explains that this unique African feminist view is not simply based on the notion that gender is primarily the focus point of women's struggles in patriarchal systems. She emphasizes that many African women "do not identify with the concept [of feminism] in its entirety and thus cannot see themselves as feminists," at least with respect to the Western definition of feminism (153). In the late 1990s, many sub-Saharan African women filmmakers worked within the framework of these women-centered agendas as a way to study the "specificity" of African women's sociocultural and political conditions (Kolawole 22).

It is within Afrocentric philosophy, developed by African scholars and philosophers in the 1980s and 1990s, that African women filmmakers conceptualized a unique perspective for the screen. Earlier women cineastes began to formulate a distinctive feminist view that pertains to the specificity of African life and women's roles within it. The filmmakers Safi Faye, Anne-Laure Folly, and the later Khady Sylla and Fatou Kandé Senghor maintain that what is essential to an African woman's identity and agency is very different from what white, western European and American feminists have struggled for since the inception of Western feminist movements.

Films such as the Senegalese Khady Sylla's *Les bijoux* (Jewelry, 1996), the Burkina Fasian Fanta Regina Nacro's *Puk Nini* (1995) and *Le truc de Konaté* (Konaté's thing, 1997), Kenyan Tsitsi Dangarembga's *Everyone's Child* (1996) and *Mother's Day* (2004), the Togolese Anne-Laure Folly's *Femmes aux yeux ouverts* (Women with open eyes, 1993), the Senegalese Safi Faye's *Mossane* (1996), and the Angolian/Guadeloupian Sara Maldoror's earlier *Sambizanga* (1972) highlight the specific interests of women, as they work within systems established by indigenous societies in order to foster change not only for women but for men too. These films also recognize the importance of cultural roots.

Women filmmakers have contended for a long time that sexual difference is but one component of their movement championing the rights of women on the continent and elsewhere in the diaspora. Female cineastes (and even some men, too, such as Sembène Ousmane and Moussa Sene Absa) underscore the important fact that women's roles within societies are constantly manipulated by problems and conflicts that arise out of race, class, and economic inequalities, generated within, as well as influenced from outside, the continent. All underscore the importance of confronting these challenges collectively through community action that engages women and men equally. The documentarian Fatou Kandé Senghor explains that it is on this collective level that women filmmakers are being heard, exerting their rights, and addressing issues that are pertinent to women across the continent (Orlando, "Voices"). Women cineastes and documentarians such as Senghor, perhaps more than men, use film to support their social agendas and struggles for change.

In addition to women filmmakers working within social-activist, women-centered frameworks, they face some of the same technical obstacles as their male counterparts. These are often compounded by less access to funding, on both local and international levels, as evidenced by the women filmmakers who comment on

their craft in the documentary *Sisters of the Screen: African Women on Film* (Beti Ellerson, 2002). Senghor points out that during a recent FESPACO festival, women cineastes from all over Africa complained that there was definitely a double standard when male and female filmmakers applied for the same sources of funding. Female festival participants repeatedly noted that women were (and still are) denied access to funding because it is widely believed that they "haven't arrived at the level of men yet." Senghor did, however, state that more equitable practices are being set into place in Kenya and South Africa.[8]

Khady Sylla's *The Jewels* (1999)

The Senegalese filmmaker Khady Sylla's *Les bijoux*, a twenty-three-minute, sixteen-millimeter film, won the Panorama du cinéma africain (Panorama of African Cinema) prize at FESPACO in 1999. The film exemplifies a work that promotes the inherent qualities of African womanist agendas. Schooled in France, Sylla received her master's in philosophy and subsequently began writing novels and screenplays full-time. After seventeen years abroad, she returned to Dakar, where she made her first film, *Les bijoux*. The filmmaker explains that her film is about four sisters negotiating life in contemporary Dakar. Although they live in a poor district of the city, the women all have varying aspirations. One sister, Absa, prepares to

go out with a rich, Mercedes-owning man. Her prepara-
tion for the evening, Sylla explains, "offers the girls with
differing personalities an occasion to attack each other"
(Keita). During Absa's preparations for her date, her
mother takes out her precious earrings. The jewelry sub-
sequently disappears, and accusations begin to fly among
the five women.

The film reflects Sylla's background as an author and
her previous literary work, which explores women's daily
lives. Her book *Le jeu de la mer* (The game of the sea,
1992), like her film, scrutinize the ambitions and desires
of women as well as certain phobias and psychological
instability that arise when confronted with arduous hard-
ship and the daily demands of African life in poverty.
Sylla's work in film is orchestrated as a book, a narrative
that exposes the imperfections in Senegalese women's
lives: "I am a writer. I couldn't live without writing. Writ-
ing plays an important role in my life. All this began first
with reading and somehow I can say that it is writing that
practically saved my life. So I cannot live without writing.
Cinema is an additional pleasure" (Keita).

Les bijoux, shot entirely in Wolof, exemplifies a social
realist film destined to speak for and to Senegalese audi-
ences, particularly women. Four sisters—Absa, Aminata,
Arame, and Aïda—and their mother, with occasional
appearances by a very timid son, are caught in an African

version of Jean-Paul Sartre's *Huis clos* (*No Exit*, 1944). The action takes place in one room enclosed by four walls. The women's conversation focuses on the sociocultural and political realities of Senegal from which they cannot escape. Poverty, class antagonisms, and tensions between traditionalism and modernity dominate the discussion shared by the mother and her daughters.

Technically, Khady Sylla's film is rudimentary. Her significant budget constraints and lack of funding either from domestic or foreign investors render the film an accomplishment of sheer will and determination. Commenting on the film, she remarks, "I went into debt in order to pay for my round-trip ticket to FESPACO, which will take time to pay off" (Keita). Although somewhat rough technically, the film is rich in message and theme and offers a powerful statement on the condition of women in contemporary Senegal. Unlike the polished, almost glitzy, productions of her male counterparts Sembène Ousmane, Moussa Sene Absa, and Mansour Wade (who have also been very successful in finding funding at home and abroad for their films), Sylla's work is raw, focusing on the eternal debate of tradition versus modernity and the social consequences for women who choose to go against the grain of social norms and customs. She is equally not shy about condemning the mismanaged, contemporary state of Senegal by corrupt politicians

who have economically run the country into the ground. Although the film is primarily pessimistic, Sylla, like other women filmmakers of Africa, strives to find the positive in an Africa that has been "cataloged as a continent of misery, famine and upheaval" (Lequeret 11). There is a degree of hope at the end of the film as Absa, in a beautiful party dress, steps out with her elegant suitor to attend a new rendition of the 1966 African Black Arts Festival, first held in Dakar years ago during what is touted as "happier times." On a macrolevel, Khady Sylla's film accurately portrays a Senegal that is conflicted, caught in a space of limbo between Western consumerism and African authenticity. Like the films of many men and women filmmakers across Africa, her story is meant to be an allegory for the contemporary lives of her country's people. *Les bijoux* does not pretend or even aspire to be a film of grandiose proportions. It simply opens a window onto several women's reality one afternoon in one of the countless poorer neighborhoods of Dakar.

In the 1990s, women filmmakers contributed a plethora of films such as the documentaries *Les oubliées* (The forgotten women, 1992) and *Femmes aux yeux ouverts* (Women with open eyes, 1994) by Togolese Anne-Laure Folly, as well as Kenyan Wanjiru Kinyanjui's 1995 film *The Battle of the Sacred Tree* and Zimbabwean Ingrid Sinclair's *Flame* (1996) about the liberation struggle in

1970s Rhodesia. These women are all well-established filmmakers who continue to work on the continent and internationally. In 2008, Manouchka Kelly Labouba became the first woman from Gabon to direct a film. *Le divorce* (The divorce) is a short, forty-minute film that scrutinizes the tensions between modern and traditional values that arise when a young couple faces divorce. The film is noteworthy for what it reveals about the socio-cultural parameters in modern Africa, which construct the behavior of young people who feel obligated to family yet are also influenced by transnational norms in the era of globalization.

Maghrebi Women Filmmakers

Maghrebi women filmmakers such as Moufida Tlatli, Nadia El Fani, and Raja Amari from Tunisia; Leila Ben-lyzid and Narjiss Nejjar, from Morocco; and the young, new-to-the scene Algerian filmmaker Sofia Djama, who all began working in the mid-1990s, have "traumatized male cineastes" who see the absence of male presence in their films as a "loss of masculine identity." Men claim that "this loss" has been a direct result, certainly with respect to Tunisia, "of the power and autonomy of Tunisian women . . . creating cultural trauma" (Brahimi 59–60). Films by Algerian women filmmakers have been partic-ularly successful at telling undocumented stories from

the recent past, certainly with respect to *les années noires* (the black years) of the civil war (enduring from 1992 to 2002) as well as present-day issues that affect women in Algerian society.

Algérie, la vie quand même (Algeria, life all the same; Djamila Sahraoui, 1998) documents the filmmaker's return to the Kabylia region, whereupon she gives the camera to her cousin in order to give a voice to disenfranchised youths. Habiba Djahnine's 2008 film documentary, *Lettre à ma sœur* (Letter to my sister) tells the story of the filmmaker's sister, Nabila Djahnine, a feminist civil rights advocate working in Tizi-Ouzou (a village in the Kabylia Mountains), who was killed in 1996 by Islamists during the civil war. Women have become the linchpin for progress and social change both on-screen and behind the camera as they challenge the "construction of the Nation-Image" that held them hostage to the patriarchal status quo in the 1970s, 1980s, and even 1990s, a status quo that defined all "gender relations in Algeria" (Hadj-Moussa 156). In films of this century, women are no longer depicted as reproductive agents and "the guardians of deeper Arab-Islamic values" (Hadj-Moussa 156); rather, they are, in this rebuilding moment of Algerian cinema, questioning, like many African female sociocultural producers, what the Cameroonian philosopher Achille Mbembe designates as "the phallus . . . and the birthing

of manhood" that were synonymous with the "birthing of the nation" in the early years of African independence ("On the Postcolony" 170).

Although Moroccan women came relatively late to filmmaking (some beginning in television in the 1970s), they have set their cinematography apart from their sisters' in Algeria, Tunisia, and elsewhere in sub-Saharan Africa. Their themes in the new millennium are socially engaged, are thought-provoking, and, with regard to male filmmakers, more readily cast women in take-charge roles, while promoting the credo of woman-centered agendas as explained earlier. We can say also that their films are less didactic than elsewhere. Films such as *Les yeux secs* (Dry eyes, 2002) by Narjiss Nejjar and *L'enfant endormi* (The sleeping child, 2004) by Yasmine Kassari promote the enfranchisement, socially, culturally, and, to some extent, politically, of women. Yet, comparing them with recent films by the Algerians Yamina Bachir-Chouikh (*Rachida*, 2002) and Djamila Sahraoui (*Barakat!*, 2006) and the Tunisians Nadia El Fani (*Bedwin Hacker*, 2002) and Raja Amari (*Satin Rouge*, 2002), Moroccan women's themes tend to be much more subtle and subdued, as Denise Brahimi explains: "When comparing Moroccan cinema to Algerian [we note that] . . . pain is expressed by silence, rather than by screams" (35). Moroccan women's recent films are, with the exception perhaps of *Marock* (2005) by

Leïla Marrakchi, aimed at audiences to encourage social activism in the mainstream, rather than to shock cultural values. Although it is difficult to defend this subtle difference, I would argue that the militancy levels in women's films in Morocco differ from those in Algeria and Tunisia because of the historical events of the past and the present (Orlando, *Screening* 125).

The films of first-generation Moroccan filmmakers such as Farida Benlyazid, Zakia Tahiri, and Farida Bourquia, as well as younger, more recent ones on the scene such as Narjiss Nejjar, Yasmine Kassari, and Leïla Marrakchi, all ask important questions, among which are the following: To what extent does women's filmmaking accurately represent the reality of the human condition in general and the feminine condition specifically in Morocco? And if filmmakers are truthfully portraying women's reality, then are they able to generate awareness and discussion within Moroccan society in order to advance sociopolitical change?[9]

Farida Benlyazid's *Women's Wiles* (1999)

Farida Benlyazid has been a pioneer in women's filmmaking in Morocco. She paved the way for women filmmakers in her home country and continues to mentor younger generations as well as to shape the filmmaking industry there. As early as the 1970s, she began writing scripts for

filmmakers such as Mohammed Abderrahmane Tazi, Jilalli Ferhati, and later, Hakim Noury (Carter 344). Her most notable scripts were for the now-famous films *Badis* (1988) and *A la recherche du mari de ma femme* (Looking for my wife's husband, 1993), both directed by M. A. Tazi. Benlyazid has written and directed her own films, the most known of which include *Une porte sur le ciel* (Door to the sky, 1987) and *Kaïd ensa* (Women's wiles, 1999) (Orlando, *Screening* 128–129).

Benlyazid shoots her films primarily in Moroccan Arabic, placing women in roles in which they are forced to "confront dramatic changes and problems in Moroccan society" (Carter 344). Often her works are retrospectives on women's place in society, dating from independence in 1956 to the mid-1990s. Her films are generally realistic, with perhaps the exception of *Kaïd ensa*, and rarely allow for "magic solutions" that will drastically alter women's designated roles in society. The filmmaker's style draws on the tenets of social realist filmmaking to reveal the inequalities in traditional practices that have impeded women's emancipation in contemporary society. "Benlyazid uses her storytelling to reveal the structures of oppression and domination, even those replicated by women themselves" (Carter 344).

In *Kaïd ensa*, a young contemporary girl is taken back in time to the epoch of the sultans by her mother, who

tells her the story "Lalla Aïcha: Merchant's Daughter," a well-known Arab-Andalusian fairy tale whose main theme shows the superiority of women over men. The film portrays a Scheherazade-type protagonist, the female storyteller par excellence, who passes her tales on to other women. Lalla Aïcha, the daughter of a wealthy merchant, is cloistered in her garden, where she studies flowers and music. Although set in the distant past and reminiscent of a tale from *1001 Arabian Nights*, Aïcha challenges how women are supposed to behave by enjoying a close relationship with her father, who admires her tenacity and strong will to get things she wants. Her formidable personality contradicts what was viewed as women's "proper" behavior at the time (although not specified, the story seems set in the eighteenth century). Lalla Aïcha also councils and acts as a business partner to her father, who relies on her financial savvy (Orlando, *Screening* 129).

One day when the heroine is in her garden, she realizes she is being watched by the son of the sultan next door. He has fallen in love with her and wants to make her his bride. However, she finds him impetuous. They play a series of "ruses" on each other that become increasingly vicious, including one in which Aïcha dresses up as a "slave from the Sudan," complete with blackface, and enters the prince's palace. She serves him tea and slips him a potion. He falls asleep, and she shaves off his

beard (the sign of a religiously pious man). He is forced to stay indoors, sequestered for seven days, in order to grow his beard back. Metaphorically, Benlyazid turns the gender tables on cloistering. As the weeks go by, neither the prince from his palace nor Aïcha from her garden will allow the other to get the upper hand in their tit-for-tat competition, which is based on the question "Are women more intelligent than men?"

The prince asks for Lalla Aïcha's hand in marriage, which she accepts, thinking she will be able to change him. He promptly puts her in a dungeon cell and commands her to give in and acknowledge that "the ruse of men is stronger than that of women." She refuses, inciting the prince to seek council from his confidant, a sage and bookseller in the medina. Aïcha cleverly has her father dig a tunnel from his house to her dungeon so that she can be with her family every day. For years, she sets traps for the prince in various disguises: as a Bedouin princess who lures him into her tent, a dancing woman who performs for him on the shore of a river, and a nomadic princess who invites him to partake of her beauty. After each tryst, she asks the prince to give her a token of his love. She also gives birth after every encounter, producing three children who stay with her father as she continues to live in her dungeon cell. The ruse of all ruses remains unbeknownst to the prince, who continues to ask her,

"Lalla Aïcha, the Humiliated One Who Lives in the Cellar, which is the cleverer, men or women?" On the day the prince decides to marry the woman who has been chosen for him by his father, the Sultan, Aïcha sends her children into his courtyard. They are bearing the gifts he bestowed on her in her various disguises. Discovering the truth, he also admits that "woman is not the object of desire but the light of God." In the end, husband and wife, as they are, come together, both acknowledging, "We are under the orders of God, and he gave strength to men and the art of ruses to women" (Orlando, *Screening* 131).

While *Kaïd Ensa* is a seemingly banal fairy tale, Benlyazid reveals to audiences certain themes that reflect contemporary dialogues on the emancipation of women in Moroccan society. The filmmaker's goal is to demonstrate to her viewers that women have always participated actively and equally in Moroccan social history. Feminism was a part of Moroccan life before the word actually existed, as Lalla Aïcha suggests in her constant reiteration of the fact that women were "sages, erudite, and members of the Sufi order" long before less favorable traditions stripped them of their rights. Like many Maghrebi women filmmakers, such as the Tunisian Moufida Tlati (*Les silences du palais,* Silences of the palace, 1994) and the Algerian Assia Djebar (*La nouba des femmes de Mont Chenoua,* The circle of women on Mount Chenoua, 1977),

Benlyazid seeks to revisit history in order to highlight women's contributions to their societies and cultures. What on the surface seems like a banal folktale is actually a social realist text that instructs audiences about the vital contributions to Moroccan society by women throughout history (Orlando, *Screening* 130–131).

NEW CONCEPTIONS AND TRANSITIONS OF THE AFRICAN SUBJECT

The majority of films made by African women on the continent, particularly in the 1990s, ring true to the tenets of social realist filmmaking. They instruct audiences by focusing on once taboo and controversial topics, from rural poverty and prostitution to divorce, repudiation, and the general challenges facing African women living between tradition and modernity in the era of globalization. Women's filmmaking promotes new conceptions of female subjecthood that are both particular and universal, indicative of changes taking place across the continent as well as in the global context. Their cinematic narratives speak for both men and women who find themselves pulled between local and domestic, as well as foreign and international, influences that have steadily become more challenging in the first decades of the twenty-first century.

In general, since the 1960s and the dawn of the post-colonial era, female and male African filmmakers have been essential players in documenting the changing contours of African society: North, South, East, and West. As this chapter has demonstrated, in the over fifty years of postcolonial filmmaking, African films have offered audiences, on the continent and internationally, a lens through which to assess and contemplate how Africa has developed socially, politically, culturally, and economically. Film has proved an essential medium for revealing to audiences worldwide the continuing challenges Africa faces as its peoples transit into the new millennium.

2

NEW AWAKENINGS AND NEW REALITIES OF THE TWENTY-FIRST CENTURY IN AFRICAN FILM

Films made in the twenty-first century "ignore the boundaries imposed by various national and international film histories" in order to embrace the universal themes of our globalized world (Gauch 9). In general, most African films made in the past fifteen years have been less politically defined within the theoretical structures of postcolonial Third Cinema that helped voice the insular nationalism of countries in the wake of independence. Contemporary filmmakers are also less shy about using commercial, international venues through which to make their films accessible to global markets (i.e., using DVD distributors instead of reserving films only for art houses and traditional-model theaters). In a sense, viewing African film as made for limited audiences who frequent art

cinemas in the West is a concept that has served its time. Third Cinema called for the dissociation—a complete decolonization of the postcolonial subject—and outright rejection of Western, "Hollywood" models and styles of filmmaking. Contemporary African filmmakers, however, have become more concerned with encouraging widespread interest in the medium so as to infuse it with new life as an effective tool to foster change in society. In an effort to attract local and global viewers, cineastes produce works that challenge and probe films' former national paradigms by mixing recognizable social realist and documentary styles with more fluid, twenty-first-century themes that speak to younger audiences. New cinematic digital technologies have made filmmaking more accessible to new generations of cineastes as camera equipment also has become smaller and more affordable. These factors all contribute to how films are made and viewed by audiences at home and abroad.

Made-for-TV miniseries such as the South African Teboho Mahlatsi's *Yizo Yizo* (This is it!, 1999–2001) and the Moroccan Nourridine Lakhmari's *El kadia* (The affair, 2006) and feature-length films by the Algerian Merzak Allouache's *Bab el-Web* (2005) and the Tunisian Nadia El Fani's *Bedwin Hacker* (2003) are thematically pleasing to international audiences because their scripts' themes and messages tend to be universal in scope. These

contemporary films also "reject imitative relationships to European, American, Asian, and Middle Eastern cinematic models," while challenging audiences' expectations based on African stereotypes (Gauch 10). The filmmakers discussed in this chapter offer films that are multidirectional and contest the paradigms of early postindependence cinema, which was dependent on the nation-state for funding and infrastructure.

As chapter 1 of this study explains, understanding contemporary African film of the twenty-first century mandates that we recognize the socioeconomic and political challenges, hurdles, advances, and setbacks that have occurred since the dawn of the postcolonial era and how they affect Africa and African filmmaking. For most African countries, whether north or south of the Sahel, this postcolonial time frame begins in the early 1960s. New African cinema is the product of the past as well as the current transnational and transcontinental stories of globalized cultures as they interact with each other. Filmmakers realize today that they are citizens of both Africa and the world. Underscoring this fact, Frieda Ekotto and Kenneth Harrow note in the introduction to *Rethinking African Cultural Production* (2015) that "African cultural production . . . [is] being produced increasingly by writers and filmmakers who live abroad. . . . Migration of cultural capital in an age of globalization tends to flow more in

some directions than in others. . . . More and more fre-
quently we have found that many of the African authors
and filmmakers whose works we study and teach do not
live in Africa: some live abroad, and some travel between
Africa and elsewhere" (1).

Ekotto and Harrow's volume, as well as others recently
published, emphasizes that contemporary cinema from
the continent reveals that "yesterday's struggles for
national liberation have passed. Movements against neo-
colonialism have passed. Pan-Africanism, Negritude, and
many other artistic, cultural, literary and philosophical
movements have passed" (1). This assessment of African
cinema, on the whole, leads us to wonder from where,
then, comes the voice of the African-globalized, trans-
continental filmmaker inspired by the happenings on
the world's stage? New technologies and new patterns
of culture have impacted cultural production on the
continent. Some of the most salient questions that Afri-
can cinema elicits today include, How do contemporary
conceptions of home and place influence film scripts?
What are the differences and commonalities between
"metropolitan-based" filmmakers living on the conti-
nent working from urban centers located in north (Casa-
blanca, Tunis, Algiers) and south of the Sahel (Dakar,
Lagos, Libreville)? How are topics such as gender and
sexual orientation being addressed in African globalized

cinema? How is film helpful in cultivating social aware-
ness about poverty and inequality on and off the conti-
nent? And, finally, "what critical approaches are adequate
to the task of assessing work" produced by filmmakers
"who live in different geographic and cultural milieus"
(Ekotto and Harrow 3)? These are just some of the ques-
tions that are explored in the visual texts produced by the
vibrant twenty-first-century African film industry.

THEORETICAL POLEMICS AND PARAMETERS INFLUENCING NEW AFRICAN CINEMA: THE AFROPOLITAN FILMMAKER

Filmmakers making films today have largely moved away
from critiquing "neocolonial relationships" with former
European colonizers (Harrow, "Towards a New African
Cinema Criticism" 309). They are more concerned with
evaluating the autocracies that their postcolonial govern-
ments have become. Thus, for these cultural producers,
the real threat to African peoples comes from the govern-
ments that are ruling over them and the corrupt practices
these governments have implemented that have suc-
ceeded in impoverishing most Africans in the past forty
years—even more so, some critics maintain, than during
the colonial era.

The very idea of the nation-state, based on the Marxist revolutionary ideals of the 1960s, proposed as cornerstones of independence by African and Afro-Caribbean intellectuals (Frantz Fanon, Albert Memmi, Kwame Nkrumah, Amilcar Cabral, Aimé Césaire, and Léopold S. Senghor, to mention only a few), have now been superseded by what the African philosopher Achille Mbembe notes is the era of the "postcolony." This postcolony stage provides a framework, allowing Africans to finally turn their backs to the colonial past in order to free themselves of the African-European dialectic that has shaped the stereotypes they have confronted for centuries. Mbembe also underscores the need for African theorists and intellectuals to dissociate themselves from "Western discourse" and their desire to "situate themselves" in relation to it ("On the Postcolony" 146). Yet the ideology of the postcolony does not propose a total *retour aux sources* (return to the sources) as preached by the fathers of the Negritude movement—Aimé Césaire, Léopold S. Senghor, and Léon Gontran Damas—in the 1950s and 1960s. In fact, Mbembe warns against the "Afro-centric impulse . . . to try to excavate the glory of things past as a means of rectifying the sorry contemporary picture of Africa" ("On the Postcolony" 147). Rather, his goal in *De la postcolonie: Essaie sur l'imagination politique dans*

l'Afrique contemporaine (2000, translated in 2001 as *On the Postcolony*) is to look at the reasons for "Afropessimism" and to strategize in order to find ways to emerge from African intellectuals' insistence on defining current socio-economic failures of African countries in terms of "lack," which stems from these same former colonial dichotomies "imagined within a web of difference and absolute otherness" ("On the Postcolony" 147). Capitalism and global markets "must be acknowledged and dealt with," and "capitalism, in its association with race, must also be read as a symptom" ("On the Postcolony" 149).

Mbembe suggests that capitalism is connected not only to African governments' failings but also to the failure of world systems that have created increasingly larger gaps between the haves and the have-nots. African theoretical approaches designed to study African culture, the arts, and politics must be conceptualized through an intersectional lens that Mbembe defines as "Afropolitan" ("Afropolitanisme"). This cosmopolitan view encompasses current African socioeconomic and political climates in the context of global issues that impact the peoples of the continent as well as human society as a whole. Following Mbembe's definition of Afropolitanism, Africa is opened up to new interpretations by the African filmmaker (or author) who sees his or her subject matter through both local and global lenses. Films, thus,

are very different from the more essentialist-based earlier-twentieth-century works promoting concepts such as Negritude and pan-Africanism:

> Afropolitanism is not the same thing as Pan-Africanism or Negritude. Afropolitanism is a stylistic, an aesthetic and a certain poetics of the world. It is a manner of being in the world which refuses, on principle, any form of victim identity—which does not mean that it is not conscious of the injustices and the violence which the law of the world inflicted on this continent and its people. It is also a political and cultural position with respect to the nation, to race and to the question of difference in general. Insofar as our States are pure fabrications (recent ones at that), they have, strictly speaking, nothing in their essence which should make us worship them—this does not mean that one is indifferent to their fate. (Mbembe, "Afropolitanisme")

In the 2000s, Mbembe's Afropolitanism "embodies both a universalistic dimension and a sensitivity to particular others" (Aboulafia 2). Afropolitan filmmakers articulate a space that is defined by the multiculturality and the ethnically diverse experiences they encounter on the continent and in the wider world. Often schooled in European philosophies, filmmakers find inspiration from two realms—the African and the European—as they ponder

philosophically what it means to be African racially, culturally, socially, economically. They seek to establish a phenomenologically grounded *being-in-the-world* that encompasses the challenges and triumphs in their own societies while they engage transnationally with others. This conceptualization of being is understood as connected and formulated by a *being-already-alongside* with others and "is not just a fixed staring at something that is purely present-at-hand. . . . [It is] fascinated by the world with which it is concerned" (Heidegger 88). This fascination leads to "intercultural scenarios" in which "two sign systems come into contact" (Nwosu 13). The contact allows for a "new mode of being" or a third way of being that is "generated from two cultural-ideological signifying fields," those of self and other (Nwosu 23). Afropolitanism thus connotes movement forward, beyond the local to consider the global, and we see this "paradigm of itinerancy, mobility and displacement" in many African films of this century (Makokha 19).

Films of this millennium, whether from North or sub-Saharan Africa, thematically reflect this intersectional Afropolitan approach. They also compel the West to cease conceptualizing Africa as a singular "heart of darkness," to use Joseph Conrad's term, cut off from the rest of humanity, but rather to see it as a continent caught up in, but also contributing to, the world systems of the

millennium. Africa has been impacted by sociocultural revolutions (Arab Springs), international and transcontinental warfare (Islamic State of Iraq and the Levant / ISIL, Al-Qaeda, and Boko Haram), food shortages, and unemployment, all of which have contributed to the displacement of over sixty million people worldwide. Film, as the following analyses suggest, is a forceful medium to document Africa's and the globe's tumultuous times.

The physical shifting of societies and the displacement of individuals because of war, famine, and poverty make African identities fluid, as forever *becoming*, constantly *in process* and evolving to accommodate the immediate stresses on precarious societies as they shift on the continent and throughout the diaspora. Films such as the Chadian Mahamat-Saleh Haroun's *Un homme qui crie* (A screaming man, 2010), Merzak Allouache's *Harragas* (The burners, 2009), and Moussa Traoré's *La pirogue* (The boat, 2012) are just some of the many films that depict these forced migrations and illegal crossings from Africa to the European continent, which have already and will continue to alter the identity of African cultures.

Afropolitan philosophy was inspired by literary movements of the African diaspora, such as *créolité* and *Antillanité*, as proclaimed in *Eloge de la créolité* (In praise of creoleness, 1989) by the Martinican writers Patrick Chamoiseau, Raphael Confiant, and Jean Bernabé and

Poétique de la relation (Poetics of relation, 1990) and *Philosophie de la relation* (Philosophy of relation, 2009) by Edouard Glissant. These texts' authors envision African identity as constantly forged in shifting patterns of interconnected webs of historical moments, influences, linguistic plurality, and immigration. Glissant's oeuvre focuses on developing a theory of "poetic relationships" wherein "relation" is conceived of as a rhizome with no beginning or end, only *middleness* between subjects, their movement fueled by the energy of difference and diversity. African filmmakers, like Glissant, demonstrate in their film scripts that there exists a multitude of *rhizomatic* connections and relationships to and between people, continents, ethnicities, and genres. "A rhizome ceaselessly establishes connections between semiotic chains, organizations of power, and circumstances relative to the arts, sciences, and social struggles" (Deleuze and Guattari 7). Filmmakers probing these connections seek answers to current sociocultural, political, and environmental issues and propose new ways of looking at globalization and its impact on African societies. They also explore possible remedies for the failures of postcolonial nations that have engendered socioeconomic disparity, political violence, and the social injustices confronted by African peoples. Films such as the Tunisian Nadia El Fani's *Bedwin Hacker* (2002) and the Algerian Merzak Allouache's

Bab el-Web (2005) look to these rhizomatic connections that are forged across borders, linguistic parameters, and social constructions in order to question the status quo framed in the West, which construes Africa as backward and without technological savvy or power.

Within the Afropolitan framework of the films discussed in this chapter, I focus on African filmmaking produced in the twenty-first century as accomplishing and/or revealing several important issues that are inherent in new African cinema. While of course there are a plethora of topics and challenges revealed in films made by filmmakers on the continent and those working out in the diaspora, these issues offer a structure through which to consider additional paths, references, and ways of analyzing, teaching, and understanding contemporary African film. In general, films reflect shifting mores and conceptions about the continent construed by African individuals as they negotiate their place in society on the continent and in the wider, global context, as the African philosopher Jean-Godefroy Bidima notes in *La philosophie negro-africaine* (Black African philosophy):

Africa is not only the domain of misery, dictators and the experimentation of fundamentalisms, it is also a terrain of possibilities, a space where individuals voice their problems on conceptual levels. Here are posed ethical problems

of justice, politics of authority, and legitimacy [through] educational communication and spiritual [venues]. [African] philosophy becomes in this framework not only a simple university activity, but *un engagement de soi* [a commitment of self] where the African interrogates his future and its uncertainties with respect to his history. (Qtd. in Ekotto 184)

Bidima, like Mbembe, envisions a new way of being African in the world on the basis of conceptions of Africanness (*africainité*)—a way of *being* African in the world. Within the scope of Bidima's philosophical books and articles, articulating a twenty-first-century African philosophy, he proposes that Africans begin considering "how best to use African traditions in order to create an African public space that fosters the flowering of critique, favoring responsible citizens and, more importantly, maintains . . . the fibers that weave the living together" ("Philosophie et traditions" 115).

To fully explore this African public space, which is artistic and dynamic, in this chapter, I consider, first, how contemporary African cinema contests existing stereotypes of the continent and its peoples that have been construed in the West; second, how new technologies are breaking down barriers between what is considered "high" and "low" art-form productions; third,

how African filmmakers' depictions of certain sensitive subjects, as diverse as terrorism and homosexuality, have allowed them to emerge from the "identity closure" of the past—a closure that has systematically pigeonholed them into nativist narratives at the expense of exploring more universal themes that are important for all audiences, both Western and African (Ekotto and Harrow 1–3); and fourth, how contemporary films from the continent are "Africanizing" subjects that were once only discussed in the West, thus making topics such as environmentalism, child welfare, sexual exploitation and trafficking, and gender-identity issues equally important and accessible for viewers at home and abroad (Ekotto and Harrow 2–3).

These areas of discussion are by no means the only ones through which to consider the films of this century. However, they do offer windows through which to assess how contemporary Africa is imparted to audiences globally, and they provide ways of understanding the trials and accomplishments of African peoples. The films of the twenty-first century reflect the work of humanist cineastes committed to responding to the challenges of humanity as a whole. This means that, as the philosopher Jean Bessière affirms, the filmmaker is "implicated actively in the development of the world, admits responsibility for what happens, [and] opens a future of action" (13).

CONTESTING STEREOTYPES

As a response to "representations," both real and imaginary, that are holdovers from "the colonial past," African cinema today challenges its own conception of itself, which was forged from what the West has wanted Africa to be (Bartlet 10). The salient question that filmmakers are asking is to what extent their responses to Western representations of Africa have stymied possibilities for exploring other themes. Increasingly, African films query and then subvert and even rupture stereotypes produced in the West that have "tended to fix a genre called 'African cinema'" in expected scenarios.[1] The French film scholar Olivier Bartlet explains that up through the 1990s, postcolonial filmmakers, in order to sell their films internationally, often reified in their scripts Western clichés of the continent and its peoples (11). For the most part, this tendency was rooted in pressures from international distributors to give Western audiences what they wanted with respect to African themes: desert landscapes and veiled women in films from the Maghreb and Black Africans in huts with thatched roofs in works from sub-Saharan regions. For many filmmakers, international funding has dictated the subjects of films, and therefore, they "run the risk of having to change their scenarios" when financed abroad mainly because "the Western

viewer becomes a major factor in the filmic equation" (Rosen 36).

Since the early 2000s, many African filmmakers have subverted expected scripts of the past. Primarily, due to shifting sources of funding, an African diaspora that both embraces African culture and rejects the stereotypical, as well as more cosmopolitan, globally connected audiences (thanks to social media, the Internet, and general media formats that extend beyond physical barriers of nation-states, linguistic parameters, and cultural taboos), filmmakers have become more savvy and discerning in their approaches to creating narratives for local and global appeal. Films such as Rachid Bouchareb's *Little Senegal* (2001), Ishmaël Ferroukhi's *Le grand voyage* (2005), and Merzak Allouache's *Bab-el Web* (2005) exemplify these trends. These films have emerged as products of transnational and transcontinental systems that are consumed by cosmopolitan audiences in urban spaces. They are characterized by "movement, perpetual displacement and exile" (Ekotto 189). Interestingly, though, exile and displacement are not always viewed as negative; thus, these films exemplify Bidima's and Mbembe's hopeful philosophies, underscoring the fact that, to a certain extent, African producers of cultural seek to avoid the pitfalls of Afropessimism in order to favor more Afropolitan views that link Africa to other

global cosmopolitan cultures (Mbembe, "On the Post-colony" 147).

Due to massive population shifts to urban centers, certainly since the beginning of the 1990s, metropolitan societies have culturally, if not always economically, become richer by the very polyglot aspects they contain within their spaces. According to the French sociologist Pierre Bourdieu's theories on cultural production, as a society grows materially and culturally cosmopolitan, it "moves . . . into new positions" that comply with the "expectations of the cultivated audience" (68). These expectations create and define a *habitus*, a "system of dispositions" that "emphasizes milieu over characters, the determining context over the determined text." In the *habitus*, the filmmaker is "sole master" of a new "complete universe" (Bourdieu 71). Filmmakers are thus free to define their habitus and to "utter in public the true nature" of what they perceive that space to be (Bourdieu 173). Cineastes' efforts to propose counternarratives pertaining to African immigration to Europe are particularly noteworthy. Whereas most films depicting the immigrant African, clandestinely trying to cross to Europe, end in tragedy, as revealed in *Frontières* (Borders; Mostefa Djadjam, Algeria, 2002), *Harragas* (The burners; Merzak Allouache, Algeria, 2009), and *La pirogue* (The boat; Moussa Touré, Senegal, 2012), others offer different outcomes. Atypical

scripts demonstrate to audiences that normalized stories depicting clandestine immigration, along with its deathly images, can be subverted to offer fresh, more positive, versions of international sea crossings and transcontinental travel. Three films in particular reveal to audiences other ways through which to view and consider alternative immigration patterns and movement across regions and continents. Each film establishes a new *habitus*, in Bourdieu's terms, where connections are made that form new assemblages of identity and culture that were rarely depicted in earlier African films. In particular, North African filmmakers have been very active in articulating divergent roles counter to the Western stereotype of illegal immigration and migrant travel throughout the world.

The Films of Rachid Bouchareb

The Algerian Rachid Bouchareb is today a multifaceted and globally connected director. Although born in France, he is claimed by Africa as an Algerian filmmaker and known for films that analyze a host of topics confronting the globe. From his first film, *Dust of Life* (1995), which studies the plight of an Amerasian youth in Vietnam after the departure of the American military, Bouchareb has continued to explore the lives of people from diverse regions across the world. From films engaging with the tendentious colonial past that still haunts France,

Algeria, and the larger Maghreb (*Hors la loi*, Outlaws, 2010; *Indigènes*, Days of glory, 2006) to the gruesome subjects of terrorism and suicide bombings by radicalized Islamists in Britain (*London River*, 2009) to the transnational links through history that can be made between Africa and the United States as portrayed in *Little Senegal* (2001), the Algerian filmmaker has become one of the most globally high profile of this century.

Bouchareb is versatile and always casts his cinematic net wide to encompass a multitude of angles. His most recent feature-length film is set in the United States and tells the story of the marginalization and impossible societal reinsertion of an ex-convict who spent eighteen years in a prison in New Mexico. *La voie de l'ennemi* (Two men in town, 2014) is Bouchareb's most internationalized film to date. A remake of the 1973 Franco-Italian *Two against the Law* (directed by José Giovanni), the credits of Bouchareb's film roll in French, but his film script was cowritten in English, Spanish, and Arabic by Olivier Lorell and the famous Algerian author Yasmina Khadra. The director uses the well-known American actors Forest Whitaker and Harvey Keitel as his lead protagonists. Bouchareb's cast is multiracial and multilingual. Garnett, played by Whitaker, converts to Islam while in prison, and when he is released, he is convinced that his faith will help set him on the right path to comply with his parole

and eventually regain some normalcy in his life. *La voie de l'ennemi* was filmed in the desolate desert of New Mexico, where Garnett is harassed by the local sheriff (Keitel) for the eighteen-year-old murder of a local police officer. Garnett is unable to fend off the demons of his past and find redemption. He eventually again succumbs to the violence from which he cannot escape. Trapped in a cycle of death that offers no exit, Garnett's tortured life ends where it began, with murder.

In general, what is particularly interesting about Bouchareb's entire cinematic oeuvre is that his work touches on universal aspects of the human condition that, no matter the continent, region, or language, are understood by all. He weaves a network of connections that allow characters to interact using universal human responses recognizable by all audiences. Although ending in violence, reminiscent of an American western, the juxtaposition of very dissimilar elements—the African American Garnett's Islam and fluency in Spanish; his friendship with his white, middle-aged parole officer, Emily Smith (played by the British actress Brenda Blethyn); and his attempts at living a life of nonviolence in the middle of a Mexican-gang-infested town in the desert Southwest—place the film in a unique category (see Weissberg).

In *Little Senegal* (2001), the lead protagonist, Kouyaté, travels from the Island of Goré, off the coast of Senegal,

where he is a tour guide at the UNESCO World Heritage site (the embarkation point where Africans were for centuries transported to slavery in the New World), to the United States, going first to South Carolina and then to New York City to search for his ancestors sold into bondage. Curiously, a striking aspect of the film is the Algerian Bouchareb's focus "on the cultural conflicts and discrimination between American blacks and new African immigrants" in America, a focus that, in turn, opens up a host of other questions dealing with immigration and the history of slavery and race in the United States (Goodstein). Africa is tied to the United States in a contemporary setting that is rarely highlighted in American-made films by Hollywood filmmakers.

Merzak Allouache's Algeria

The Algerian Merzak Allouache's *Bab el-Web* (2005) is a comedy playing on the title of his very bleak 1994 film *Bab el-Oued City*, which chronicles the rise of the radical fundamentalist Front Islamique du Salut (FIS, the Salvation Islamic Front) in the early 1990s. Conflicts in Algeria between members of the FIS and the Algerian government ultimately led to civil war, which endured throughout the 1990s. Allouache's later film *Bab el-Web*, which is much more humorous and lighthearted, announces the emergence of a country from fifteen years of blood-

shed, while characterizing the hope of young people as they make international connections over the World Wide Web. Additionally, traveling happens in the opposite direction, from France to Algeria, when Laurence, a young Frenchwoman, comes to visit Algeria seeking answers to her Algerian father's whereabouts.

The film highlights to what extent young people are able to make connections across physical borders and languages via the Internet and social media. Kamel and his brother, Bouzid, live in Bab el-Oued, the poorer section of Algiers (known for being a haven for the fundamentalists of the FIS in the 1990s and, earlier, as a bastion for the FLN rebels who fought for independence against the French from 1954 to 1962). While Kamel is a brooding loner, disillusioned by poverty and lack of prospects in Algeria, his younger brother, Bouzid, is happy-go-lucky and an aficionado of the Internet, spending most of his time in a cybercafé. During his chat sessions, he talks mainly with girls from all over the planet. With every conversation, he invites them to Algiers, hoping that in return, one will reciprocate, inviting him to her country, so that he can immigrate. Laurence finally accepts his invitation, much to his chagrin, since he never thought his invites would bear fruit. He is embarrassed by his family's poverty and wonders how he can properly host her when he has no money. Certainly, how to house Laurence while

living with his entire family in a tiny apartment becomes a major conundrum that must be tackled by Bouzid and his brother. The film stresses not only that Algeria has come out of a long civil war but also that in 2004 the country endured massive flooding and an earthquake, causing significant loss of life. These catastrophes were followed by water shortages and electrical outages complicated by enduring housing scarcity.

As the film progresses, we understand that Bouzid and Laurence live *à l'envers* (oppositely) with respect to their families' French-Algerian histories. Laurence's father was Algerian, though she never knew him well. Bouzid's father worked in France, living there with his family until Bouzid was ten, when, all of a sudden, his father decided to return to Algiers. Bouzid does not "understand why [his father] all of a sudden decided to return and start from zero." On a metalevel, the film reveals the conflicted identities of younger Algerian-French generations who seek better lives beyond the conflicts and tensions of the past that continue to haunt them in the present. The film promotes investment in freedom of movement from one side of the Mediterranean to the other as a means to continue dialogue and overcome differences between two countries whose histories will be forever entwined.

After Laurence finds her Algerian father in Algiers, she eventually goes back to Paris. However, she immediately

sends a message inviting both Bouzid and Kamel (with whom she has fallen in love) to visit her on her side of the sea. Although made in the climate of 9/11 and immediately following the United States' invasion of Iraq in 2003, the film sets the tone for a happier time that disregards barriers between "us" and "them," in order to explore the possibilities of friendships built on love and shared histories and also future common interests.

Ismaël Ferroukhi's Moroccan Journey

Perhaps the most emotionally moving film of those discussed in this chapter is the Moroccan Ismaël Ferroukhi's *Le grand voyage* (The long journey, 2004), which documents travel not between Europe and Africa but from France across Turkey to the Middle East and Mecca. The film is unique for the universal humanist messages it reveals. These include the internationalism of Islam as a religion of peace and how important it is for people of all faiths, in the new millennium, to be tolerant. Ferroukhi has been one of the few filmmakers allowed into Mecca to film the hajj. This singular experience aids the filmmaker's goal of promoting Islam as a religion that brings together millions of diverse people from all corners of the world. *Le grand voyage* leaves a lasting impression on audiences that effectively subverts today's stereotyping of Islam and Arab peoples in our post-9/11 world. Moreover, *Le grand*

voyage is a film that counters the West's general view of Islam as hostile and unforgiving and as a religion that promotes only bombs and terrorism (Orlando, *Screening* 50). The script focuses on a French-Moroccan teenager, Réda (who has lived all his life in Marseille, France), who is forced by his very traditional father to accompany him on a pilgrimage to Mecca. The defining difficulty for Réda is that his father insists on making the trip by car. Midway through the film, Réda obliges his father to tell him why he did not want to go by plane. The father replies. "God says . . . to go by foot, and if not by foot, by mule, and if not by mule, by car." In short, it is better to choose the most laborious path in order to retain the purity of the hajj (Orlando, *Screening* 50). Réda's journey is arduous for several reasons. First, he cannot connect with his father's Moroccan past because he does not know the culture or how to speak the language. Second, raised in secular France, the young man does not, or cannot, appreciate his father's spiritual devotion.

Ferroukhi's first feature-length film offers a story line structured within a humanist perspective, focusing on some of the most poignant international topics of our era. It is a film that scrutinizes the contemporary challenges of our time and seeks to rectify the miscomprehension we have about others (not only Westerners' perceptions about Muslims but also the socioeconomic disparities

between Muslims across the world), all the while dispelling the notion that we are incapable of living with one another in peace. The work reflects what Edward Saïd suggests is a new "discourse [on] humanism" that challenges the "canonical" in order to propose "unwelcome interventions" of the status quo that defines the world in which we live (23). Not only is Réda's relationship with his traditional father tendentious, but he also faces the hurdles of assimilation into secular French society as a young, second-generation Maghrebi who shares little with his parents' homeland or their former life in Morocco. The young man's love for a non-Muslim, white French girl, whose picture he longingly looks at throughout the film, is also another aspect of life in France that his father finds difficult to accept.

Once in Mecca, Réda and his father come to terms with their differences and heal their relationship. Metaphorically, the unity of Islam is depicted with wide-panning shots of young Réda being absorbed into the throngs of people on the hajj as he searches for his father, who, several days after their arrival, does not return from the last leg of his pilgrimage, the walk to the Kaaba. Réda's absorption into the mass of humanity present in Mecca is crafted with deft camera work and wide-angle aerial shots, showing the young man in a yellow T-shirt and jeans, very Westernized in his demeanor, being engulfed

by thousands of serene pilgrims in white robes and head scarves. Although standing out, Réda is surrounded by a multiculturalism that is also unified, metaphorically evoking the idea that faith allows believers from all parts of the globe to come together in peaceful harmony.

Réda later finds his father in the morgue. Expatriating the body back to France, he takes not only the memory of his father's last journey with him but also a newly found comprehension of his own *being-in-the-world* with respect to his religion, homeland, and heritage (Orlando, *Screening* 51–52). Ferroukhi's film suggests that people are compassionate and that, often in our contemporary world, we ignore this singular human trait. The film's text is both a secular and spiritual humanist project that, as Saïd notes, "constructs fields of coexistence rather than fields of battle" (141). Such a work must promote the idea that, again according to Saïd, "peace cannot exist without equality; this is an intellectual value desperately in need of reiteration, demonstration, and reinforcement" (142).

BREAKING BARRIERS BETWEEN "HIGH" AND "LOW"; OR, POPULAR VERSUS CLASSICAL CINEMA

No longer is African cinema concerned with promoting itself as "high art" or as *le 7ème art* (the seventh art), a popular French term that has been associated with

cinema in the former French colonies of North and West Africa. The emergence of *un cinéma populaire* (mainstream but also low-budget cinema), generated thanks to affordable video cameras, allowing for minimal budgets, has augmented the capacity for anyone to make films outside the traditional, national cinema frameworks originally established in postcolonial countries in the 1960s. From Nollywood in Nigeria to TV *polars* (crime dramas) in Morocco and TV soaps in South Africa, low-budget filmmaking has changed the face of how cinema functions within developing countries and how filmmaking is viewed as an art form (or not) by audiences of the millennium (Bartlet 11).

The videos of Nollywood, as mentioned in chapter 1 of this book, are of course what come to mind when discussing low-budget popular cinema in Africa today. In Nigeria, the popularity of television as the primary platform for transmitting cinema to mass audiences has continued to grow in the new century. YouTube, which now carries the most recent Nollywood and Ghanaian "Ghallywood" movies, lists its 2016 lineup from which viewers can access full-length films. Titles such as *Chisom the Hustler*, *American Igwe 1*, *Baddest Queen Ever Liveth 1*, and *Generational Curse 1*, to note only a few, are glitzy and colorful, incorporating sensational, over-the-top musical scores, action, sex, and generally anything one can imagine possible for a

film script. Yet, as the scholar Ganivu Olalekan Akashoro emphasizes, while Nigerian videos have become "a veritable platform for home entertainment," they should not be considered as a replacement for films meant for theaters (29). In both Nigeria and Ghana, these "two platforms are meant to exist . . . as complementary alternatives" (Akashoro 29). In South Africa, audiences' preferences since the country's 1994 independence have tended to favor merging television and classic cinema-styled films,[2] thus cultivating the predominant popularity of soap-opera-like TV serials (Akashoro 29).

South Africa's *Yizo Yizo*

South Africa's blended television and cinema-styled film productions have offered audiences very interesting miniseries and soaps in recent years. In two works on South African postapartheid cinema, Martin Botha and Litheko Modisane suggest that despite "audience development programs" for cinema and theaters, preference for television is winning out over theatergoing among viewers (Botha 17). Audiences' heightened interest in made-for-television miniseries was particularly evident with the popular *Yizo Yizo* (This is it!, 1999–2001), "a state-commissioned, three-season television series" that addressed problems in the township schools in South Africa (Modisane, *South Africa's* 14). This popular series

(now available on YouTube) for many South Africans proved to be an effective tool for sparking community engagement and opening up national discussions about race and identity in a country still in the throes of reconciliation in the early 2000s. The popularity of this particular series demonstrates television's ability to sustain "audience interest" more than classic cinema-styled films (Modisane, *South Africa's* 14).

Yizo Yizo was the first thirteen-part series to be aired on prime-time television in postapartheid South Africa (Gevisser 27). The drama was spread over two seasons, from 1999 to 2001, and was noteworthy for a variety of reasons. The plot focuses on a fictional township school, Supatsela High, and "charts the progress of the school's [pupils] and teachers as they grapple with violence" caused by gangs, which extort, rape, and harass students in the school. The series also focuses on more generalized unrest due to inherent poverty in townships (Modisane, "*Yizo Yizo*" 122). Modisane notes that "while *Yizo Yizo I* is about violence, *Yizo Yizo* 2 looks more at ordinary people's struggles to learn, play, change, read, love, dream, and find their place in the world" ("*Yizo Yizo*" 122). The series, viewed by over two million people, generated massive national debates across generational, ethnic, and class lines. It was controversial, dividing the population between those who condemned the series's episodes for

being too violent and those who applauded them for at least engaging with critical social issues that needed to be discussed in postapartheid South Africa. On a cinematographic level, the series "compels us to reflect seriously on precisely the meanings and implications of the public critical role of film" in Africa today (Modisane, "*Yizo Yizo*" 133). The social realism of the miniseries suggests a certain "public critical potency" that underscores the "capacity of screen-based media, particularly television and film, to stimulate critical engagements in public" (Modisane, "*Yizo Yizo*" 123).

What is most interesting about *Yizo Yizo* is that it was funded by the South African Broadcasting System (SABC) with the support of the South African Department of Education in the hopes of sparking debate about violence in township schools as well as black identity in postapartheid South Africa. However, the violence portrayed (rapes of young girls, prison rape, homosexuality, drugs, guns, and corporal punishment) made audiences question the SABC's goals with respect to fostering a meaningful, educational lesson: "It was the most controversial television program to have been aired in this country since the 1994 passage to democracy. Black intellectuals accused the young director, Teboho Mahlatsi,[3] of being a Tarantino wannabe willfully degrading his own community in the name of art, and many parents accused

the government of funding a program that glamorized gangsterism and violence" (Gevisser 27).

In addition to these criticisms, many viewers wondered if the series relied too much on stereotypes of black culture as violent, held over from the apartheid era. Yet *Yizo Yizo* was also so popular because it followed a recognizable style that appealed to audiences. "Soaps with a message" have been common in South Africa, with popular films such as *Soul City* and *Khululeka* also broadcast through the SABC (Gevisser 29). This latter series transmitted sociocultural and political messages that inspired meaningful conversations in the public sphere; focusing on topics such as HIV and domestic violence (Gevisser 29). Since 1994, the African National Congress (ANC) has viewed the power of television as highly useful for building a postapartheid society. Because television was not introduced to the country until 1976 and was never made widely available to black South Africans, the medium was particularly important as a postapartheid symbolic tool for education. Subverting the SABC's historical function as a platform for the apartheid government to promote its "lethal mix of state propaganda and schlock commercialism" was one of the primary goals of the independent ANC government (Gevisser 29). Immediately in 1994, one of the first aims of the ANC was to open up the airwaves in order to promote democracy

to the entire South African population; thus, television became an essential tool in building the country and has remained so up to today. It can be said that, unlike in the West, where television is often criticized for its "capacity to numb, simplify, distort and disempower the world over," for South Africans, this same medium is viewed as an integral part of generating a new society (Gevisser 29).

El kadia, the Moroccan *Polar* (Crime Drama)

Much like made-for-TV miniseries in South Africa, Morocco too has used the television miniseries to educate wider audiences who cannot afford to go see films in cinemas and who are challenged by illiteracy and rural geographies that limit access to public venues. Over one-third of the Moroccan population owns a TV set and has access to domestic and satellite stations. In 2006, the Moroccan filmmaker Nourredine Lakhmari was asked by 2M, the principal state-run TV network of Morocco, to write and direct nine episodes of a *polar* (French for "crime series"), called *El kadia* (The affair) to be aired during Ramadan. The series was influenced by American TV crime dramas such as *CSI*, *Bones*, *Cold Case*, and *Body of Proof*. Its hard-boiled plots—albeit simplistic, violent, and extremely graphic—touch on a host of social messages in addition to the overarching one that states that women can be tough police officers and have a place in the fast-paced

modernity that characterizes the Morocco of this millennium. Additionally, on the technological level, Lakhmari brought filming techniques and themes to Moroccan TV that had never been seen before.

El kadia features Zineb Hajjami, a female forensic police officer who, much like her American female counterparts—Temperance Brennan in *Bones*, Beckett in *Castle*, and the like— profiles murderers through the latest technical innovations and scientific inquiry in order to solve heinous crimes. Beautiful, feminine, analytical, and intellectual, Hajjami represents a new generation of law-enforcement professionals who aspire to found a more just and transparent system of law and order in Morocco. Lakhmari's often didactic dialogues between Hajjami and her fellow officers touch on a host of social messages, including that women can be police officers, differences between classes can be overcome, the socio-cultural divide between urban and rural regions does not mean that justice cannot be served, and most importantly, that Morocco can aspire to cultivate a police culture that is dedicated to protecting human rights. More specifically, the series expresses to audiences that times are changing and Morocco can be wiped clean of corruption.

All the episodes of *El kadia* were shot with a hand-held camera that follows the characters' every move. Glitzy scenes of Hajjami in her lab, scrutinizing gory

cadavers after she cuts them open in order to find motives for murder, dominate the fast-paced plots. Lakhmari's successful series, ironically shown during the spiritual holy month of Ramadan, demonstrated that Moroccan television was now influenced by global trends. Series revolving around violent crime were no longer the purview of Western imports; they could now be made easily at home. In a country whose murder rate is exceedingly low, pop-culture pundits, commenting in newspapers and magazines, worried if fiction would influence reality.

The first episode of the miniseries focuses on a particularly violent incident. Inspector Hajjami is sent to investigate a young woman's murder in the remote village of Aïn Leuf in the Atlas Mountains. As a quintessential "action chick," recognizable by all contemporary audiences the world over, Hajjami "reinscribes notions of Western and white heteronormative superiority," thus evoking "West-is-best" narratives (Tung 106). Her looks are a composite of cosmopolitan whiteness and urban savvy that remind audiences of *La femme Nikita*, the universal, globally recognized standard model (even in Morocco) for the modern action chick (Inness 7). Another overarching theme is that women's roles and places within urban culture, as found in Casablanca, are associated with the most modern aspects of Moroccan society. The messages that Lakhmari transmits also include the idea that the

cosmopolitan, urban, more equality-based, Westernized populations inhabiting the gleaming cities of Casablanca and Rabat will be the generators of modern positive sociocultural and political reforms.

Filmed entirely in Moroccan Arabic, the series presents audiences an overview of past history and present sociocultural and political hurdles as well as reflects the positive evolution of human-rights reforms in twenty-first-century Morocco. This evolution has influenced judicial and police procedural ethics (certainly with respect to cleaning up corruption and police brutality). What is most interesting about the series is that it projects what Morocco is and, at the same time, what it aspires to be on many fronts, ranging from women's emancipation to uncorrupted, fair, and just police procedures. In the first episode, Hajjami is sent by the police commissioner in Casablanca to investigate the murder because she is considered "the best man for the job." Upon her arrival in the mountain village, she is cross-examined by the local sheik, Sidi Abbas, who has come to meet the "detective from the city" at the bus stop. However, he has no idea that the "he" is, in fact, a "she." Hajjami counters his total shock when she tells him, "Mr. Abbas, there is no other *man*. I'm the man you're waiting on. . . . Times have changed." This particular episode, like all the others that follow, ends with Hajjami solving the crime. More symbolically, as this conversation reveals,

the series also entreats contemporary audiences to think about Morocco's sociocultural and political culture wars and the divisions that need to be rethought between men and women, urban and rural, and rich and poor classes.

Lakhmari's series, although glitzy and graphic like South Africa's *Yizo Yizo*, uses television as a popular medium to tell stories that encourage audiences to think about the challenges facing their societies in the new millennium. These television productions from divergent regions in Africa demonstrate that the medium is a powerful tool, enabling filmmakers to educate viewers who do not possess the means to see films in cinemas. As these productions exemplify, television is able to influence social norms, practices, and political tides in society in ways that are not possible through conventional made-for-theater films. Many scholars have suggested that series such as these can also be effective models for encouraging behavioral change and founding societal institutions that will be responsible for assuring justice and equality in developing countries.

GETTING AWAY FROM "IDENTITY CLOSURE": THE AFRICANIZATION OF UNIVERSAL THEMES

African cinema has been significantly influenced by African writing, which has become increasingly transnational,

dissociating itself from themes that evoke, as mentioned earlier, a certain "identity closure" captured in recognizable scenarios of African victimization (the very kind from which we must, as Mbembe stresses, dissociate ourselves). In an interview for *Ciné 24*, on the website Dailymotion, the filmmaker Safi Faye emphasizes the fact that for her, "cinéma est comme l'écriture" (cinema is like writing). "Mes films parlent d'ethnologie, à travers eux, j'essaye de porter l'Afrique au-delà de ses frontières" (My films speak of ethnology, through them I try to take Africa beyond its borders).[4] She explains that it is important for audiences who cannot read to be able to "read" films visually in order to extend their knowledge beyond the boundaries of the continent. In the larger diaspora, just as African writers living abroad in exile (particularly in Paris) from the early 1930s forward used their metropolitan experience to intellectualize beyond the prison of colonial stereotypes, so too have filmmakers utilized their films to "distance themselves" from traditional African themes that label Africans as always suffering (Ekotto 188).

Filmmakers, like authors who travel, identify more readily with other immigrants of the world as free agents who are actualizing the multiple, transnational encounters they are living in an Afropolitanized world (Ekotto 188). "Literature and the written word do have tremendous

value to Africans . . . and film adaptations of literature are worthwhile" because they allow the filmmaker, like the author, to focus interest on "social realities and the re-historicization of the past," telling about this past through the African perspective, rather than the European (Dovey 10–11). Whereas the African literary work is limited by an audience that must be educated enough to read literature (and, often, in French or English), a film or TV screen is much more audience accessible.

Like authors, filmmakers working today are looking beyond past scenarios that revolved around the angst of the postcolonial condition, the traumas rooted in tensions between modernity and traditionalism, the sociocultural and economic divisions between North and sub-Saharan Africa, poverty, and despair (Orlando, "Transnational" 1). The African scholar Evan Maina Mwangi, referring to new, engaging twenty-first-century African writing from the continent and the diaspora, remarks that authors today are "neither . . . 'writing back'" to the West nor endorsing "Euro-American neocolonialism." They are engaging first and foremost with a "self-perception" that allows for both examination of "emerging issues" and "self-interrogation." Writers are "prioritizing themes other than the relation between colonizer and the colonized" (4). Like African writers, filmmakers are scrutinizing Africans' relationships between local and transnational

communities, attempting in their works to "transcend local boundaries in a move to forge a sense of cosmopolitanism" as well as to write new stories to counter those that "disempower Africa and render it incapable of participating in modernity" (Mwangi 24–25).

African film today reflects much of the "self-perception" to which Mwangi alludes. Filmmakers are "Africanizing" film themes and dialogues, making cinema from the continent more readily accessible to non-African spectators. Africanization means that the filmmaker "exerts pressure on the spectator" to question accepted notions associated with the division between "'inside' and 'outside'" the continent, thus compelling audiences to consider African themes as universal ones, emanating from our common human condition (Prabhu 21). Current films, much like the literature written by African authors, are reeducating the instincts of audiences and readers to understand that in the past,[5] "African subjects on screen" (or in a text) were allowed to be viewed only as "black subjects in a medium" that was first "developed to show white subjects" (Prabhu 21). The two films that I discuss next exemplify new, original thematic explorations that reveal the Africanization— the melding of African with Other—in order to explore topics important for all audiences in our era. The Moroccan Abdellah Taïa's *L'armée du salut* (Salvation army, 2015) discloses a young boy's struggle with his homosexuality,

a once-taboo subject in Morocco. The Tunisian Nadia El Fani's *Bedwin Hacker* (2002), a film known for its political messages about terrorism and the power of the Internet, features an atypical techno-savvy female character who seeks to change the perceptions of her country as passive and ineffectual on the world stage.

Abdellah Taïa: Depicting Homosexuality in Morocco

L'armée du salut, adapted from the Moroccan Abdellah Taïa's 2006 novel of the same title, is the author-turned-filmmaker's first feature-length film. The film is also the first in the country ever made about homosexuality. Debuting in February 2014, the film thus far has been widely shown in theaters across Morocco. *L'armée du salut* is for the most part autobiographical. Despite its very sensitive subject, exposed in a country where homosexuality is still considered illegal and punishable by prison time, the film was not censored. It was, however, the target of protests led by the conservative, Islamic Parti du Justice et Développement (PJD, Party for Justice and Development), which called for its removal from screens. Authorities were not swayed by the conservative politics of the PJD; the film stayed in cinemas across Morocco.

As a coming-of-age story about a young boy embracing his homosexuality and the difficulty of expressing his sexual orientation in a society that is very much entrenched

in and structured by traditional gendered roles, the film opened up new areas of discussion across Morocco. For many Moroccans, upholding the sociocultural divisions between men and women is imperative. However, these divisions, certainly for younger generations, are becoming increasingly difficult to accept in a world connected by the Internet and social media. Thus, Taïa suggests that his film is not only about social alienation because of sexual orientation but also about the disenfranchisement of young people who seek to be different by challenging traditional mores. The filmmaker notes this fact in an interview: "This film corresponds to my vision about life in Morocco and how this country treats its individuals, whether hetero or homosexual, . . . in how it strangles their aspirations and their true freedoms" ("Le film").

L'armée du salut is divided into two parts. The first focuses on a young Taïa, living and coming of age in the late 1980s in Salé, a somewhat disenfranchised, working-class suburb of Rabat. During this time, he engages in his first homosexual encounters with older men in back alleys and behind half-built walls on empty construction sites in his neighborhood. The second chapter transitions to an older Taïa who has embraced his homosexuality through several sexual liaisons with men. These relationships include one with Jean, a Swiss man on holiday in Morocco. At Jean's invitation, Abdellah ends up leaving

Morocco to pursue his studies in Switzerland. However, upon his arrival, he refuses to rely on help from Jean, whom he sees at the university but denies needing. In a heated argument, Abdellah tells Jean that "he explained everything in his letter" as to why he no longer wants to continue their relationship. Audiences are not privy to what has been said in the letter or what the ultimate understanding becomes between the lovers. Jean accuses Abdellah of being "an opportunist" and for having "taken advantage of him." Abdellah notes that he has arrived in Switzerland because of his academic success through dedicated hard work at the University of Casablanca, where he obtained his first diploma. Jean can no longer "keep him" as he did in Morocco. Abdellah wants nothing from his former lover. Taïa's message extends past a simple quarrel between gay lovers to convey the more comprehensive message that most immigrants to Europe do not seek handouts and that until Europeans consider them in another manner, they will be caught in stereotypes rooted in misunderstandings, sexual fantasy, xenophobia, and racism.

Upon Abdellah's arrival at the university in Geneva, he is told that he is a month too early to claim his student grant money. Without resources, he finds himself alone, in the cold, rainy, isolating streets of Geneva with nowhere to go. By way of chance, he happens on the Salvation

Army shelter for homeless and/or wayward travelers, many of whom are African immigrants. It is in the Salvation Army dormitory that Abdellah metaphorically finds the "salvation" he seeks, not only as a place to sleep safely but as a space of freedom where one is recognized as an individual, first and foremost, in a community of men whose marginalization and alienation—not because they are homosexual but because they are "foreign"—forge the very human bonds that young Abdellah has sought throughout his life.

Although Taïa's film is primarily about homosexuality and coming of age in Morocco's traditional culture, it also touches on other themes associated with this North African–Mediterranean country that are important yet rarely seen on-screen in the films made by European filmmakers. Poverty and the continuous sexploitation of Moroccan youth by European sex travelers, who are primarily French speaking (coming from France, Belgium, and Switzerland), are themes woven into the subtext of the film. Although Morocco has made significant progress in curtailing and prosecuting sex offenders (particularly sexual tourists), the country has by no means been able to completely stop the practice. The trafficking of both Moroccan girls and boys by Europeans, as well as Saudis, is a sociopolitical subject that has been increasingly the topic *du jour* in the cultural production

of Morocco—depicted in films such as the recent *Much Loved* (2015) by Nabil Ayouch, as well as novels and social media.[6] Taïa's film adds a layer of nuance, making one young boy's homosexuality part of the larger, continuing subject of rich, capitalist powers' exploitation of less powerful developing nations in our era of rapid globalization.

While the constraints of cinematographic time compelled the author to cut many of the scenes detailed in his novel, Abdellah's arduous journey to arrive at a place where he could defy social norms and ultimately claim his homosexual identity without fear of repercussion, detailed in the novel, is no less painful on the screen. Not only is this a story about claiming one's identity and right to be homosexual, but it is also about the human need for recognition as an individual and for companionship and community, no matter one's sexual preference.

Nadia El Fani: Being High-Tech in Tunisia

The film *Bedwin Hacker* by Nadia El Fani proposes a transnational view of the globalized world in which two cultures—French and Tunisian—are pitted against each other in an age of Islamic radicalism, terrorism, and Western capitalist neocolonialism. El Fani's film was one of the first to raise issues from a Maghrebi perspective about the extent to which the world has been fragmented by

geopolitical, sociopolitical, and technological clashes in the 2000s. Since the film's release, this fragmentation has become even more evident. The filmmaker delves into the farthest reaches of our cultural fears and misunderstandings to demonstrate that in the age of cyber terrorism, no country or people is unaffected by the clash of cultures constantly taking place in our era.

Kalt, the heroine of the story, is a cyber activist who sets her sights on drawing attention to "the complacency, racism, and capitalist greed" occurring in the West, which, in turn, has adversely affected people in the developing world. On one level, as the scholar Robert Lang remarks, El Fani's film is a political treatise against global capitalism; on another, it is a reflective commentary on Tunisia's suffocating political system before the Arab Spring of 2011, which altered the country forever:

> Tunisian viewers undoubtedly recognize that the film is as much a complaint about how countries like theirs can become victims of a first-world neocolonialism that prevents them from becoming as free and prosperous as a country like France, as it is a critique of the Tunisian state's own paranoid insecurities, especially as these are reflected in the regime's efforts to monitor all electronic exchanges of information among Tunisians and its attempt to have total control over how they use the Internet. (192)

Bedwin Hacker is Nadia El Fani's first feature-length film and was released almost ten years before Tunisia exploded in the first Arab Spring. Toppling the regime of Ben Ali, Tunisia's Arab Spring was a harbinger for things to come. Not only is the film monumental for having been made by a young woman filmmaker, but it also was released just as the country entered the digital age. Since the early 2000s, Tunisia has focused on cultivating digital know-how and cyber expertise, making it one of the most technologically advanced countries in Africa: 6.4 percent of the total population uses the Internet, placing it "above the North African average of 2.8%" (Lang 201). Despite the setbacks caused by social unrest and political upheaval, the country has made some headway with respect to developing software companies and encouraging young techies, although these young entrepreneurs often say they are hampered by bureaucracy and infrastructure weaknesses (Shahani).

El Fani's film projects both reality and fiction with respect to what Kalt is able to achieve as she plots and executes her cyber messages for the global community. The film opens in the middle of the Tunisian desert, where the very savvy female computer hacker is hiding out in an oasis. Her first and foremost goal is to hijack as many foreign airwaves as she can in order to broadcast the message in Arabic: "In the third millennium, other periods, places,

and lives exist. We are not mirages." On the other side of the Mediterranean, Julia, alias Agent Marianne of the French cyber police, is plotting her own strategy to combat Kalt. Ironically, Julia looks very much like a French version of Kalt, thus reminding French viewers how much they have in common through their Mediterranean genes and histories infused by centuries of colonialism and immigration. Both women sport short black hair and exude a tomboy-like or even, we could say, androgynous persona, dressed in similar khaki army pants and shirts. Julia sends her French, ethnically Maghrebi boyfriend, Chams, back to Tunisia on reconnaissance because she recognizes Kalt as her once-friendly rival when they were in college together. Chams ends up taking Kalt's side, sleeping with her and working to help her dodge the French cyber bureau's hunt for her. Both young women are remarkable in their likeness as they exude confident attitudes, fight as foes, and reminisce about their former lesbian relationship. Kalt and Julia, playing with their fluid sexuality, at once lesbian and heterosexual, both subvert passive feminine and feminized stereotypes of women (Western and Arab). Up to the last scenes of the film, Kalt is able to outwit Julia, effectuating frequent cyber attacks on TVs and computers in Europe, much to the appeal of immigrant groups there that take to heart the antineo-colonialist, capitalist messages.

Bedwin Hacker reveals certain tropes that are recognizable in Europe's new millennium, particularly, the favorite: French fears of invasion by the North African other. This familiar narrative plagues Maghrebi immigrants and their children, born and raised in France, who consider themselves French. On another, more symbolic level, the cineaste's message "also registers a keen disappointment in the failure both of decolonization and the transformation of culture brought about by globalization to change the rules of repression and oppression" both from within and outside North Africa (Lang 193). For Tunisia, El Fani's film celebrates the possibility of other norms and champions the "what ifs" possible in the cyber age. In the context of the 2011 Arab Spring for which Tunisia was ground zero, it announces the eventual overthrow of a repressive government whose authorities used every means possible in the information age to block access to "human rights websites, information websites, and . . . political opposition websites" (Lang 201).

The two Maghrebi films *L'armée du salut* and *Bedwin Hacker*, as well as the others discussed in this chapter, demonstrate the Africanization of topics that are now pertinent to all globally connected societies. Like authors, African filmmakers too are exploring their being in the world as Africans, drawing on their self-perceptions in order to confront sociocultural challenges pertaining to

identity and sexuality as well as political and economic hurdles in "an agglomeration of systems we call late capitalism" (Lang 215).

IMMIGRATION, EMIGRATION, AND THE ENVIRONMENTAL CATASTROPHES OF OUR TIME

Known as the "father of African cinema," Sembène Ousmane said in 2004 that "le siècle que nous abordons est le siècle le plus dangereux" (the century that we are beginning is the most dangerous of centuries; qtd. in Bartlet 18). As cineastes in the West, African filmmakers are concerned with depicting the local and global pressures that impact individuals and their societies in the twenty-first century. One of the challenges of our era for the African filmmaker is how to build new cinematic models that consider humankind in all its dimensions. African cinema will be a tool to help audiences see how to develop human capabilities to address the socioeconomic as well as the environmental challenges confronted by the continent's populations (Bartlet 12). Like many African writers (Wole Soyinka and Niyi Osundare from Nigeria, Ngiug wa Thiong'o and Ali Mazruifor from Kenya) who have voiced concerns about the continent's natural environment, African filmmakers have also become outspoken ecocritics. The critical role these ecocritics play

in providing an environmentalist, humanist framework for the cultures in which they live is increasingly evident as the planet becomes more compromised by climate change. These frameworks also evoke questions about agency and subjectivity as the filmmakers consider how natural environments shape the lives of individual Africans: "Most ecocritics insist on a concern for nonhuman others that mandates an involvement in current controversies about agency, subjectivity, moral standing, and a host of competing and contesting ecological causal models that often resist simplification and clarification. Ecocritics and authors of environmental literature often espouse political and philosophical agendas that criticize human intervention in and instrumentalization of nature" (Slaymaker 129).

Ecocriticism in the African context is "concerned with [the] domination of cultural markets" by globalization. For example, what are the effects of economic globalization on "local artisans who wish to remain loyal to regional cultures and not switch allegiance to nation-states artificially created by Europeans and their African puppets" (Slaymaker 134). Perhaps no other cultural producer better understands how fragile the balance is between the local and the global than the African eco-critical filmmaker. From the massive immigration and emigration we are witnessing at the current time to the

environmental catastrophes taking place not only on the continent but elsewhere all over the globe due to manmade climate change, filmmakers are documenting the upset of many balances that cause catastrophes planetwide. Films such as *Harragas* (2009) by the Algerian Merzak Allouache, *La pirogue* (2012) by the Senegalese Moussa Traoré, and *Un homme qui crie* (2010) by Mahamat-Saleh Haroun document the bone-chilling stories of millions of people on the move as they flee conflict, poverty, drought, and famine.

The Mauritanian Abderrahmane Sissako's *Bamako* (2006), set in the courtyard of a mud-walled house in Bamako, the capital city of Mali, promotes a dialogue among Africans dedicated to civil society as they take action against the World Bank and the International Monetary Fund (IMF), which they directly blame for Africa's woes. From exploiting the goods that Malians make to imposing incredible debt structures from which local economies cannot emerge unscathed, the West has been the cause of many of the contemporary calamities plaguing Africa. The film blends traditional music, while unfolding scenes very slowly in order to reveal the multifaceted challenges facing a country that has been beleaguered by famine, war, and poverty for decades. In general, Sissako's films, including his most recent, *Timbuktu* (2015), comment on how violations of land and the

natural environment, as well as violence to traditional life in this region of Africa, often caused by radicalized Islamist groups such as Boko Haram and ISIL (Islamic State in Iraq and the Levant), are decimating local populations. These hurdles and how they are addressed will have lasting consequences on the continent and, even, planetwide for years to come.

THE ECOCRITIC FILMMAKERS BASSEK BA KOBHIO AND DIDIER OUÉNANGARÉ: CULTIVATING THE SILENCE OF THE FOREST

Le silence de la forêt (The forest, 2003) by directors Bassek ba Kobhio (Cameroon) and Didier Ouénangaré (Central African Republic) was filmed in the Central African Republic (CAR) and Gabon. The screenplay was written in French and Sango, one of the indigenous languages of the region. The film highlights several salient points about the natural environment in this region, as well as explains how indigenous people's lives and values are impacted by modernity. It also has been characterized as "a film about the difficulty for even the most well-intentioned person to know and respect another culture."[7] Based on the 1961 novel *The Forest People* by Colin Turnbull, the film's hero, Gonaba, unlike many Africans educated in Europe, decides to return to his homeland, Gabon. He

returns as a schoolteacher, full of ideals for fulfilling the promises made in the heyday of independence. The film fast-forwards ten years, and we find a seasoned, wiser, but more disillusioned Gonaba, now chief inspector of schools. He slowly realizes that as an official of the state, he has accomplished nothing. "If anything he has become just another parasitical bureaucrat entitled to his own servant, comfortable house and sexual dalliances."[8]

Gonaba is a "tall man" (a Bantu from the city) educated in France. He returns to Africa to "do something good for his country." Recognizing his own complicity in the postcolonial corrupted system of Gabon, he believes that changing the status quo will be the only way to ensure an education system that is equitable for all, even in the most remote areas of the region. He is particularly concerned about the "Pygmies" (a pejorative term that is nevertheless used by Gonaba and others in the film when speaking in French and is translated with the same term in the English subtitles), whom he perceives as having been sidelined to the lowest rungs of Gabonese society due to their "primitive" ways of living. Although humorous at times, the film also offers, through Gonaba's own blundering stereotypes and somewhat pejorative views of the Pygmies, an instructional, ethnographic narrative framework.

The "Babingas," as they are also known, is a term that carries similar negative connotations to the word

"Pygmy." As the story unfolds, we learn that the proper name of the "people of the forest" is Aka or Moaka (singular) and Baka (plural).[9] These are the small-statured people who inhabit the tropical rainforests in the interior region of Gabon and the Central African Republic. They are hunter-gatherers living in ways that are very traditional—or "primitive," as city dwellers characterize them. The subtle confusion over designations that leads to racist views is one of the primary themes of the film. Moreover, the cineastes make sure that audiences understand that contemporary racism in Africa and views of otherness and the other are postcolonial manifestations that have little to do with skin color and more to do with global, modern, and sometimes, Western influences that mold contemporary thinking. The film's messages posit the cold, hard truth that racism and classism do exist among Africans.

In Gonaba's European-educated formulations concerning equality, he is incensed by how the Baka people are treated by the postcolonial Gabonese government. This postcolonial institution is incarnated by the military leader known as "Le Prefect" (the prefect), who employs and exploits them as second-class citizens to perform in their tribal dress their "original, authentic dances" at his lavish parties. Gonaba's French-influenced views, molded by the philosopher Jean-Jacques Rousseau's belief in

human equality, lead him to condemn the postcolonial corruption he sees around him. He scolds the corrupted Prefect for "treating the Baka like animals." The racism against the Baka forest people is widespread in post-colonial Gabon.

While out in the region on a school inspection, Gonaba meets with the chief of one of the villages, who has a Baka "slave" named Manga, whom he mistreats. The chief's behavior toward Manga provokes Gonaba's indignation once again. In a tête-à-tête with the Baka youth, Gonaba reminds him that in postcolonial Gabon, he is a citizen and "that all people are equal as the founder of the Central African Republic, Barthélemy Boganda, preached." After "buying" Manga in order to free him, Gonaba convinces him to show him the way to the Baka people in the forest so that he can educate and empower them. Gonaba believes the forest dwellers to be "primitive" but also still possessing "their integrity." He will educate them with what he takes for granted "as the universal wisdom of the French Enlightenment." Manga protests that he cannot go back to his village because he promised his tribe that he would become a military man, a position of power that he views as the only kind available to him in the "tall man's world." Manga deserts Gonaba, leaving him to fend for himself in the forest. He is eventually found by Manga's tribe.

For the remainder of the film, Gonaba tries to educate the Baka so that "they will have power. . . . Knowledge is power." Attesting to the altruism and genuine humanity of the villagers, he is accepted by the tribe; marries a woman, Kali; and has a child. Although in some respects, he "goes native," Gonaba also refuses to relinquish his superior air, rooted in what he perceives as an enlightened modernity. He insists on continuing to try to school the Baka children despite the protests of the chief, who tells him, "The children don't want your white man's knowledge; they want to know the truth of the world."

For a while, Gonaba seems to be able to mix the modern with the spirituality of the Baka people in his daily life. Yet he often feels marginalized, lonely, and ostracized. He genuinely cannot seem to heed the elders' advice, which would ultimately help him to adapt more effectively. He is constantly trapped by his "modern" ways of thinking and his inability to set aside his "civilization" for the Baka's more fluid way of life. In the end, Gonaba's modern haughtiness has dire consequences. His refusal to heed the chief's advice not to "build his hut so large and so far from the center of the village" results in the death of his wife when a storm brings down a tree that crushes their home. Grief stricken, Gonaba realizes that he is and always will be an outsider and that "only the Baka can live

in the forest." He leaves defeated, returning to the city with his baby in his arms.

The film not only touches on the clash between modernity and indigenous life but also explores the spirituality of the vast West African forest, preaching the need for the respect of nature in order for humankind to survive. Even the Baka realize that "the great spirit exiled them to the forest, ... where only the gorilla took pity on them." There is a constant balance that must be preserved between man and the wilderness, yet this is something that Gonaba is unable to totally grasp. The hero does come to realize and appreciate the "silence" everywhere in the forest. This silence, he notes, cannot be replicated anywhere else and is totally unattainable in the urban world. As he emerges from the forest, after losing all notion of time ("Is it one, two, or three years I've lived in the forest?" he rhetorically asks), taking the main road leading to the dusty, noisy city, he realizes that he will never know this silence again because it is uniquely part of the vast forests that man is rapidly encroaching on and exploiting.

The films analyzed in this chapter attest to the equal growing concern among African filmmakers for their natural and social environments. Since the 1990s, eco-critical approaches to cultural production have provided

frameworks through which to scrutinize the socio-
economic and political choices that impact peoples and
their natural environments across the continent. Pop-
ulations in the cities of Africa have increased threefold
since most countries' independence in the 1960s–1970s,
straining what little infrastructure existed in cities such as
Lagos, Dakar, Casablanca, Nairobi, and Algiers. As mas-
sive migrations because of war and famine push people
off their lands and as population explosions and continu-
ous unbridled exploitation of fragile ecosystems continue
to occur, filmmakers realize the necessity of revealing
to audiences at home and abroad the precariousness of
Africa's natural environment. What will be the environ-
mental consequences of inaction? As one woman states in
Sissako's *Bamako*, pleading her case against the "exploita-
tion of Africa," "Africa doesn't owe anything to the West,"
and it is time that the continent "takes care of itself."

CONCLUSION
The Futures of African Film

I hope that this short work on contemporary African cinema has succeeded in opening a window onto some of the most pressing issues explored in films from across the continent. The cinematic works explored in these pages demonstrate that the 1960s narratives of independence from colonialism have been transformed into critical inquiries and commentaries concerning the challenges, hurdles, and failures of postcolonial nations in the first decades of the 2000s. The international pressures of global markets, neoliberal economic pressures, civil wars, famine, and displacement resulting in massive migrations have influenced the themes of African filmmakers north, south, east, and west. Twenty-first-century Afropolitan filmmakers conceptualize cinema as a medium that is effective for representing the actuality of their time, as they instruct audiences worldwide about the hurdles and issues facing contemporary Africa. This means both questioning the sociopolitical nepotism and corruption of

state authorities and giving voice to the voiceless of their respective countries: women and children, and ethnic and religious minorities. New African film industries are "informed by a vision of cultural diversity and an intention to empower" African peoples more than ever since decolonization (Botha 248).

Although speaking about South African cinema in particular, Martin Botha makes a significant observation that is applicable in general to filmmaking on the continent: "The development of an economically sustainable cinema to which multiple, progressive and dynamic national identities are formulated and consumed by the majority of the population requires [dedication to] infrastructure" (249). The social and environmental fragmentation of many countries in recent years, caused by the aforementioned calamities, now more than ever have jeopardized the creation of sustainable infrastructures. Needless to say, filmmakers recognize that they are crucial to contributing much-needed visual art forms to document this fragmentation and the tensions between tradition and modernity, the West and Africa, the rural and the urban, and the local and the transnational.

Technological advances, social media, and the general transnational connections that can so easily be made in our era have also influenced how filmmakers make their films and how they depict their realities. The future(s)

of African filmmaking will depend on the sociopolitical influences that compel cineastes to make certain choices that ultimately will have lasting impacts on their countries' respective cinema industries. From Nigerian videos and Moroccan *polars* to South African soaps, the very form of cinema has, with newer generations, mandated new conceptions of what film should be and how it functions in society. These original ways of making films, or what we could call "visual texts," also have transformed the way Africans see their identities and conceptualize their agency in the world. Mwangi's ideas about Africans' "self-perception" as the driving force behind African writing today lends itself well to articulating the modus operandi of filmmakers (4). This self-perception for today's generation of cineastes is rooted in recognizing that African identity is formed through both relationships forged on the continent and the global connections that the individual is able to make with others.

The films discussed in this book, only a few among so many, demonstrate "how we must be prepared to move intellectually between worlds, to be simultaneously here and there, to be aware of the ways in which [cinematic] texts both expose and occlude duality. We need to interrogate what we understand African . . . cinema to be, and, more important, we need to reevaluate and reshape our own critical approaches" to and views of

this art form (Ekotto and Harrow 16). It is through these new twenty-first-century approaches to film that filmmakers are documenting and bearing witness to not only the hurdles and atrocities occurring on their continent but also the positive realities of a dynamic region of the world as it formulates the "what ifs" and the "could bes" of future generations.

ACKNOWLEDGMENTS

I would very much like to thank Professors Wheeler Winston Dixon and Gwendolyn Audrey Foster for having asked me to contribute this work to the Quick Takes series and, in general, for their appreciation of my scholarship in African cinema over the years. Additionally, I would like to thank the faculty in the Film Studies Program at the University of Maryland for their wonderful collegiality, vitality, and inspiration, particularly my dedicated and supportive colleagues: Valerie Anishchenkova, Hester Baer, Caroline Eades, and Elizabeth Papazian. Last, a big thanks to all my students in the Film and French Studies programs, from whom I derive a source of energy every day.

NOTES

INTRODUCTION

1. The film is available on YouTube at https://www.youtube
 .com/watch?v=4ceXYa2u4d4.
2. In 1986, there were approximately four hundred cinemas
 operating in Algeria; by 2004, only ten remained open
 to screen films. During the civil war period, audience
 attendance fell dramatically, from forty million annually
 to only fifty thousand (Dwyer and Tazi 10). Since the
 end of the civil war, cinemas have been renovated, and
 Dolby Digital systems have been installed. El Mougar,
 Ibn Zeydoun, and ABC theaters in Algiers, as well as one
 cinema in Tizi Ouzou, are of top quality. However, as
 the filmmaker Yamina Bachir-Chouikh noted in 2003 in
 an interview, these "newly renovated cinemas are empty
 because there aren't any films to show in them" (Lequeret
 and Tesson 31).
3. The Sahel is the semiarid region of western and north-
 central Africa, extending from Senegal eastward to the
 Sudan. This band, crossing under North Africa, "forms
 a transitional zone between the arid Sahara desert to the
 north and the belt of humid savannas to the south." The
 geographical area of the Sahel is huge, extending "from
 the Atlantic Ocean eastward through northern Senegal,

southern Mauritania, the great bend of the Niger River in Mali, Burkina Faso (formerly Upper Volta), southern Niger, northeastern Nigeria, south-central Chad, and into The Sudan." "Sahel," *Enyclopædia Britannica*, accessed 6 Oct. 2016, https://www.britannica.com/place/Sahel.

4. "North Africa" and "the Maghreb" are regional designations fraught with American and European geopolitical conundrums. In the U.S. geopolitical mind-set, North Africa usually encompasses not only the three countries Algeria, Morocco, and Tunisia but also Egypt, Syria, and the Sudan. In the French context, "le Maghreb" signifies the three former colonies of France: Algeria (1830–1962), Morocco (1912–1956), and Tunisia (1881–1956). I use the two terms interchangeably here to make a point about geopolitical views promoted by Europe and the United States. My use of terminology such as "Maghrebi authors and filmmakers," though, is understood as having origins in France's three former colonies.

5. *Petit blanc* is a derogatory term for white settlers generally of the lower classes who are often illiterate or have limited schooling. In colonial Algeria, many of these *petits blancs* lived in the poorest areas of Algiers. Albert Camus, the famous Algerian-French author, comes from this milieu but was able to escape it through education.

6. *Pied-noir*, plural *pieds-noirs* (literally meaning "black feet") is a term referring to people of French and other European ancestry who lived in French North Africa, particularly French Algeria and the French protectorates

in Morocco and Tunisia. The name has persisted,
characterizing still today the descendants of the former
colonizers who left in 1962 to return to France and other
parts of Europe because they were no longer welcome in
the Maghreb.

7. La fémis is public, and the ESEC is private.

8. FEPACI's official website outlines its vision this way:
"FEPACI's purpose is to help in the further cultivation
and nurturing of the audiovisual sector with the aim of
catapulting it into a powerful cultural economy where
there is a liberating economic capacity to create and
deepen the understanding and appreciation of Africa's
purpose of being by Africans themselves. FEPACI is
to encourage ownership and control of Africa's image
and imagination, the preservation of its heritage, its
common history, its memory, its diverse indigenous
cultures and languages while promoting its contem-
porary artistic creative expressions." SPLA, "FEPACI
(Fédération Panafricaine des Cinéastes)," accessed 6 Oct.
2016, http://www.spla.pro/en/file.organization.fepaci
-federation-panafricaine-des-cineastes.2086.html.

9. Slam films are primarily made in urban settings with little
crew and are fifteen to twenty minutes in duration. There
are now slam film festivals all over the world.

CHAPTER 1. FROM REVOLUTION TO THE COMING OF AGE OF AFRICAN CINEMA, 1960s-1990s

1. The mujahidin were the rebel fighters of the Front de
Libération Nationale (FLN; National Liberation Front),

who fought the French, leading Algeria to independence in 1962.

2. During the Lead Years and Hassan II's reign, it is estimated that over thirteen thousand people disappeared, condemned as communists or because they championed the right to freedom of speech and expression in the country. Torture, imprisonment, and massive clampdowns on freedom of speech were everyday occurrences in Morocco from 1963 to 1999. Those who received the brunt of this oppression were artists, philosophers, intellectuals, authors, and filmmakers. Since 2000, under the new king, Mohamed V, Hassan II's son, the sociopolitical climate of Morocco has greatly improved.

3. Algeria's cinematic production was viable and imaginative from 1962 to the late 1980s but then was virtually halted during the bloody civil war that endured from roughly 1990 to 2003. By 1993, at the height of some of the bloodiest years of this conflict, the Algerian film industry and all film productions were seriously threatened (Armes, *Postcolonial* 55).

4. The NEH seminar held in Dakar, Senegal, in June 2005 was organized by Manthia Diawara (New York University) and Mbye Cham (Howard University). During the seminar, attendees had the opportunity to meet and hear speak numerous leading African filmmakers, among whom were Sembène Ousmane, Gaston Kaboré, and Moussa Sene Absa.

5. One of the first women on the continent to make films was Egyptian Aziza Amir, who made *Layla* in 1927. She also played the leading role.

6. African Women in Cinema, "Safi Faye (1943–)," accessed 7 Oct. 2016, http://www.africanwomenincinema.org/ AFWC/Faye_Pfaff.html.

7. Portions of this section are from my article "Voices of African Filmmakers."

8. See *Sisters of the Screen* here: https://www.youtube.com/ watch?v=303hMoNeoSk.

9. For a more comprehensive discussion of women's film-making in Morocco, see my book *Screening Morocco*.

CHAPTER 2. NEW AWAKENINGS AND NEW REALITIES OF THE TWENTY-FIRST CENTURY IN AFRICAN FILM

1. However, it is debatable whether African filmmakers' efforts to combat stereotypes have any impact on Holly-wood. A case in point is the 2016 remake of *Tarzan*, which a reporter for the *Guardian* characterizes this way: "There is . . . the uncomfortable optic of this glorious white couple being cheered and paraded around by their happy, loving black pals. There are at least half a dozen images begging to be used as internet memes. Admit-tedly, this is no way to watch a film, but image-making is what it is, and *The Legend of Tarzan* is going to make a lot of people feel uncomfortable" (Hoffman). This most recent production of *Tarzan*, like those in the past, is set in the Belgian Congo of the early twentieth century. Also like these former productions, it does not reveal that King Leopold of Belgium murdered over eighteen million Congolese when he ruled that part of Africa. For an interesting discussion about this very

un-politically-correct film with respect to the reign of King Leopold in the Congo, see also Bacon.

2. By "cinema styled," I am referring to a traditional conception of film: films using thirty-five-millimeter film stock, made with certain lighting and sound techniques that are particular to films destined for theaters. Of course, even most films shown in theaters are now made with digital cameras, which are effectively able to mimic traditional film, thus making it hard to tell the difference.

3. While Teboho Mahlatsi was the principal director, he was aided by Desiree Makgraaf and Angus Gibson, who worked to produce the series.

4. Africa24, "CINE24—Sénégal: Safi Faye, réalisatrice," Dailymotion, 5 Sept. 2016, http://www.dailymotion .com/video/x49ev62_cine24-senegal-safi-faye -realisatrice_news.

5. This fact, for example, is most evident among authors writing in French, such as Salim Bachi (France/Algeria), Abdelaziz Belkhodja (Tunisia), Calixthe Beyala (Cameroon), Youssouf Amine Elalamy (Morocco), Fouad Laroui (Morocco), Alain Mabanchou (Congo), Marie Ndiaye (France/Senegal), and Abdourahman Waberi (Djibouti), to list only a few. Authors writing in English, such as the Nigerian Helon Habila, the Kenyans M. G. Vassanji and Shailja Patel, the Libyan Hisham Matar, and the Zimbabwean Brian Chikwava, also promote a "way of being African in the world" that thematically exposes different attitudes about Africa and Africans that are remarkably unlike previous tropes. See my article "Transnational Turn."

6. *Much Loved* was the first film banned in Morocco since 1999. The film was controversial not because it showed the raw underbelly of prostitution, sex acts on-screen, and lewd language but because it revealed police corruption and implication in the Moroccan drug trade. The film has been shown widely in international festivals and won a prize at the 2015 Cannes Film Festival.

7. California Newsreel, "Le silence de la forêt (The forest)," accessed 11 Oct. 2016, http://newsreel.org/video/LE-SILENCE-DE-LA-FORET.

8. Ibid.

9. The Baka people are known in the Congo as Bayaka (Bebayaka, Bebayaga, Bibaya).

FURTHER READING AND
USEFUL WEBSITES

Bartlet, Olivier. *African Cinemas: Decolonizing the Gaze*. New York: Zed Books, 1996.

Diawara, Manthia. *African Film: New Forms of Aesthetics and Politics*. Berlin: Prestel Verlag, 2010.

Eltringham, Nigel, ed. *Framing Africa: Portrayals of a Continent in Contemporary Mainstream Cinema*. New York: Berghahn Books, 2013.

Gugler, Josef. *African Film: Re-imagining a Continent*. Bloomington: Indiana UP, 2003.

Higgins, Maryellen, ed. *Hollywood's Africa after 1994*. Athens: Ohio UP, 2012.

Thackway, Melissa. *Africa Shoots Back: Alternative Perspectives in Sub-Saharan Francophone Film*. Bloomington: Indiana UP, 2003.

Ukadike, Frank Nwachukwu. *Questioning African Cinema: Conversations with Filmmakers*. Minneapolis: U of Minnesota P, 2002.

African Film New York: http://www.africanfilmny.org/.

YouTube Nollywoood 2016 films: https://www.youtube.com/results?search_query=nollywood+full+movies+2016.

WORKS CITED

Aboulafia, Mitchell. *The Cosmopolitan Self: George Herbert Mead and Continental Philosophy*. Urbana: U of Illinois P, 2001.

Akashoro, Ganivu Olalekan. "The African Filmmaker and Content of African Films: A Study of the Perspectives of the Nigerian Film Audience." *Global Media Journal African Edition* 4.1 (2010): 1–32.

Andrade-Watkins, Claire. "Portuguese African Cinema: Historical and Contemporary Perspectives—1969–1993." In *African Cinema: Post-colonial and Feminist Readings*. Ed. Kenneth Harrow. Trenton, NJ: Africa World, 1999. 177–200.

Armes, Roy. *African Filmmaking: North and South of the Sahara*. Edinburgh: Edinburgh UP, 2006.

———. *Postcolonial Images: Studies in North African Films*. Bloomington: Indiana UP, 2005.

Austin, Guy. *Algerian National Cinema*. Manchester: Manchester UP, 2012.

Bacon, Tom. "The Historical Accuracy of 'The Legend of Tarzan.'" *Movie Pilot* 14 July 2016. http://moviepilot .com/posts/3996608.

Bartlet, Olivier. *Les cinémas d'Afrique des années 2000: Perspectives critiques*. Paris: L'Harmattan, 2012.

Bensmaïa, Réda. *Experimental Nations; or, The Invention of the Maghreb*. Princeton, NJ: Princeton UP, 2003.

Bessière, Jean. *Les écrivains engagés*. Paris: Librairie Larousse, 1977.

Bidima, Jean-Godefroy. *La philosophie negro-africaine*. Paris: PUF, 1995.

———. "Philosophie et traditions dans l'espace public africain." *Cahiers Sens Public* 2.10 (2009): 113–132.

Bonner, Michael David, Megan Reif, and Mark Tessler. *Islam, Democracy, and the State in Algeria: Lessons for the Western Mediterranean and Beyond*. London: Routledge, 2005.

Botha, Martin. *South African Cinema: 1896–2010*. Bristol, UK: Intellect, 2012.

Bourdieu, Pierre. *The Field of Cultural Production*. New York: Columbia UP, 1993.

Brahimi, Denise. *50 ans de cinéma maghrébin*. Paris: Minerve, 2009.

Canby, Vincent. "'Ceddo,' a Pageant from Sembene's Africa: Stately Power Struggle." *New York Times* 17 Feb. 1978. http://www.nytimes.com/movie/review?res= 980CE3DF1530E632A25754C1A9649C946990D6CF.

Carter, Sandra. *What Moroccan Cinema? A Historical and Critical Study, 1956–2006*. Lanham, MD: Lexington Books, 2009.

Chamoiseau, Patrick, Raphael Confiant, and Jean Bernabé. *Eloge de la créolité: In Praise of Creoleness*. Baltimore: Johns Hopkins UP, 1989.

Deleuze, Gilles, and Félix Guattari. *Mille plateaux: Capitalisme et schizophrénie*. Paris: Editions Minuit, 1980. Trans.

Brian Masumi. *A Thousand Plateaus*. Minneapolis: Minnesota UP, 1987.

Diawara, Manthia. *African Cinema: Politics and Culture*. Bloomington: Indiana UP, 1992.

Dovey, Lindiwe. *African Film and Literature: Adapting Violence to the Screen*. New York: Columbia UP, 2009.

Ekotto, Frieda. "La mondialisation, l'immigration et le cinéma africain d'expression française: Pour un devenir moderne." *Nouvelles Etudes Francophones* 24.1 (Spring 2009): 184–198.

Ekotto, Frieda, and Kenneth W. Harrow. Introduction. *Rethinking African Cultural Production*. Ed. Frieda Kotto and Kenneth W. Harrow. Bloomington: Indiana UP, 2015. 1–16.

Eltringham, Nigel, ed. *Framing Africa: Portrayals of a Continent in Contemporary Mainstream Cinema*. London: Berghahn Books, 2013.

Fanon, Frantz. *The Wretched of the Earth*. Trans. Constance Farrington. New York: Grove, 1965.

Gabriel, Teshome. *Third Cinema in the Third World: The Aesthetics of Liberation*. Ann Arbor, MI: UMI Research Press, 1982.

———. "Towards a Critical Theory of Third World Films." *Questions of Third Cinema*. Ed. Jim Pines and Paul Willeman. London: BFI, 1989. 30–52.

Gauch, Suzanne. *Maghrebs in Motion: North African Cinema in Nine Movements*. Oxford: Oxford UP, 2016.

Gevisser, Mark. "South Africa Says, Yizo Yizo!" *Nation* 29 Nov. 1999: 27–29.

Glissant, Edouard. *Philosophie de la relation*. Paris: Galli-
mard, 2009.

———. *Poétique de la relation*. Paris: Gallimard, 1990.

Goodstein, Jack. "Movie Review: *Little Senegal*." *Blogcritics*
6 Sept. 2011. http://blogcritics.org/movie-review-little
-senegal/.

Hadj-Moussa, Raiba. "The Past's Suffering and the Body's
Suffering: Algerian Cinema and the Challenge of Expe-
rience." *Suffering, Art, and Aesthetics*. Ed. Raiba Hadj-
Moussa and Michael Nijhawan. New York: Palgrave,
2014. 151–176.

Harrow, Kenneth. "Towards a New African Cinema Criti-
cism: From the Truth to *Déchets humains*." *International
Journal of Francophone Studies* 14.3 (2011): 307–321.

———. *Trash: African Cinema from Below*. Bloomington:
Indiana UP, 2013.

Haynes, Jonathan. *Nollywood: The Creation of Nigerian Film
Genres*. Chicago: University of Chicago Press, 2016.

———. "Nollywood in Lagos, Lagos in Nollywood Films."
Africa Today 54.2 (2007): 131–150.

Heidegger, Martin. *Being and Time*. Trans. John Macquarrie
and Edward Robinson. New York: Harper and Row, 1962.

Higgins, Maryellen, ed. *Hollywood's Africa after 1994*. Ath-
ens: Ohio University Press, 2012.

Hoffman, Jordan. "The Legend of Tarzan Review—An
Inherently Problematic Remake." *Guardian* 29 June 2016.
https://www.theguardian.com/film/2016/jun/29/
the-legend-of-tarzan-review-an-inherently-problematic
-remake.

Hudson-Weems, Clenora. "Africana Womanism." *The Afro-centric Paradigm*. Ed. Ama Mazama. Trenton, NJ: Africa World, 2003. 153–163.

Inness, Sherrie. "Boxing Gloves and Bustiers." *Action Chicks: New Images of Tough Women in Popular Culture*. Ed. Sherrie Inness. New York: Palgrave, 2004. 1–17.

Keita, Modibo. "Écrivain, cinéaste: Mme Khady Sylla: Interview." *Amina* 351 (July 1999): 44–46. Accessed 7 Oct. 2016, http://www.arts.uwa.edu.au/AFLIT/AMINAScylla99.html.

Kolawole, Mary. *Womanism and African Consciousness*. Trenton, NJ: Africa World, 1997.

Lang, Robert. *New Tunisian Cinema: Allegories of Resistance*. New York: Columbia UP, 2014.

Lazreg, Marnia. "The Perils of Writing as a Woman in Algeria." *Theorizing Feminism: Parallel Trends in the Humanities and Social Sciences*. Ed. Anne Hermann and Abigail Stewart. Boulder, CO: Westview, 2001. 321–344.

"Le film de Abdella Taïa sélectionné au festival de Tanger." *Tanger Experience* 18 Jan. 2014. http://www.tanger-experience.com/culture/cinema-culture/le-film-de-abdellah-taia-selectionne-au-festival-de-tanger/.

Lequeret, Elisabeth. "Un monde de combats, de rêves et de désirs: L'Afrique filmée par des femmes." *Le monde diplomatique* Aug. 1998: 11. http://www.monde-diplomatique.fr/1998/08/LEQUERET/10795.

Lequeret, Elisabeth, and Charles Tesson. "Yamina Bachir-Chouikh." "Où va le cinéma algérien?" Special issue, *Cahiers du cinéma* Feb.–Mar. 2003: 26–31.

Makokha, J. K. S. "Introduction: In the Spirit of Afropolitanism." *Negotiating Afropolitanism: Essays on Borders and Spaces in Contemporary African Literature and Folklore.* Ed. Jennifer Wawrzinek and J. K. S. Makokha. Amsterdam: Rodopi, 2011. 13–22.

Mazama, Ama. *The Afrocentric Paradigm.* Trenton, NJ: Africa World, 2003.

Mbembe, Achille. "Afropolitanisme." *Africultures* 66 (14 Dec. 2008). http://www.africultures.com/.

———. *De la postcolonie: Essaie sur l'imagination politique dans l'Afrique contemporaine.* Paris: Karthala, 2000. Trans. *On the Postcolony.* Berkeley: U of California P, 2001.

———. "On the Postcolony: A Brief Response to Critics." *African Identities* 4.2 (2006): 143–178.

Megherbi, Abdelghani. *Les Algériens au miroir du cinéma colonial.* Algiers: SNED, 1982.

Meleiro, Alessandra. "Cinema, Lusoafro cinema." *Afroscreen* 24 Aug. 2012. http://www.buala.org/en/afroscreen/luso-african-cinema-nation-and-cinema-editorial-of-journal-of-african-cinemas.

Modisane, Litheko. *South Africa's Renegade Reels: The Making and Public Lives of Black-Centered Films.* New York: Palgrave, 2013.

———. "*Yizo Yizo*: Sowing Debate, Reaping Controversy." *Social Dynamics* 36.1 (Mar. 2010): 122–134.

Mudimbé, V. Y. *The Invention of Africa: Gnosis, Philosophy, and the Order of Knowledge.* Bloomington: Indiana UP, 1988.

Mwangi, Evan Maina. *Africa Writes Back to Self: Metafiction, Gender, Sexuality.* Albany: SUNY P, 2009.

Mwijuke, Gilbert. "Rwanda's Film Industry on the Rise." *East African* 17 July 2014. http://www.theeastafrican. co.ke/magazine/Rwanda-s-film-industry-on-the-rise/ -/434746/2390080/-/8jh1dj/-/index.html.

National Film and Video Foundation South Africa. *South Africa's Box Office Report, Mid-Year: 2015.* Houghton, South Africa: National Film and Video Foundation. http://nfvf.co.za/home/22/files/Box%20Office%20 Report%20-%20Half%20Yearly%20Final%202015.pdf.

Nwosu, Maik. *Markets of Memories: Between the Postcolonial and the Transnational.* Trenton, NJ: Africa World, 2011.

O'Riley, Michal. *Cinema in an Age of Terror: North Africa, Victimization, and Colonial History.* Lincoln: U of Nebraska P, 2010.

Orlando, Valérie K. *Screening Morocco: Contemporary Film in a Changing Society.* Athens: Ohio UP, 2011.

———. "The Transnational Turn in African Literature of French Expression: Imagining Other Utopic Spaces in the Globalized Age." *Humanities* 18 May 2016: 1–12. doi:10.3390/h5020030.

———. "Voices of African Filmmakers: Contemporary Issues in Francophone West African Filmmaking." *Quarterly Review of Film & Video* 24.5 (2007): 445–461.

Pines, Jim, and Paul Willeman, eds. *Questions of Third Cinema.* London: BFI, 1989.

Prabhu, Anjali. *Contemporary Cinema of Africa and the Diaspora.* New York: Wiley- Blackwell, 2014.

Rosen, Miriam. "The Uprooted Cinema: Arab Filmmakers Abroad." *Middle East Report* (July–Aug. 1989): 34–37.

Saïd, Edward. *Humanism and Democratic Criticism*. New York: Columbia UP, 2004.

Shahani, Aarti. "Tunisia's Emerging Tech Sector Hampered by Old Policies." *NPR.org* 20 Oct. 2014. http://www.npr.org/sections/alltechconsidered/2014/10/20/357590073/in-tunisia-democracy-doesn-t-create-jobs.

Slaymaker, William. "Echoing the Other(s): The Call of Global Green and Black African Responses." *PMLA* 116.1 (Jan. 2001): 129–144.

Steady, Filomina Chioma. "An Investigative Framework for Gender Research in Africa in the New Millennium." *African Gender Scholarship: Concepts, Methodologies, and Paradigms*. Ed. Signe Arnfred, Bibi Bakare-Yusuf, and Edward Waswa Kisiang'ani. Dakar: Council for the Development of Social Science Research in Africa, 2004. 42–60.

Sylla, Khady. *Le jeu de la mer*. Paris: L'Harmattan, 1992.

Tazi, Mohamed Abderraham, and Kevin Dwyer. *Beyond Casablanca*. Bloomington: Indiana UP, 2004.

Tebib, Elias. "Panorama des cinémas maghrébins." *Notre Librairie* 149 (2000): 60–66.

Treffry-Goatley, Astrid. "South African Cinema after Apartheid: A Political-Economic Exploration." *Communication* 36.1 (2010): 37–57.

Tung, Charlene. 2004. "Gender, Race, and Sexuality in *La Femme Nikita*." *Action Chicks: New Images of Tough Women in Popular Culture*. Ed. Sherri Inness. New York: Palgrave, 2004. 95–121.

Turnbull, Colin. *The Forest People*. New York: Simon and Schuster, 1961.

Ukadike, Nwachukwu Frank. *Black African Cinema*. Berkeley: U of California P, 1994.

Weissberg, Jay. "Berlin Film Review: 'Two Men in Town.'" *Variety* 7 Feb. 2014. http://variety.com/2014/film/festivals/berlin-film-review-two-men-in-town-1201091531/.

Yamoah, Michael. "The New Wave in Ghana's Video Film Industry: Exploring the Kumawood Model." *International Journal of ICT and Management* 2.2 (Oct. 2014): 155–162.

SELECTED FILMOGRAPHY:
TWENTY-FIRST-CENTURY FILMS

Allouache, Merzak. *Bab el-Web* (2005).

———. *Harragas* (The burners, Algeria, 2009).

Amari, Raja. *Satin Rouge* (Red satin, Tunisia, 2002).

Anuka, Kensteve, *Baddest Queen Ever Liveth 1* (Nigeria, 2016).

Ayouch, Nabil. *Much Loved* (Morocco, 2015).

Bachir-Chouikh, Yamina. *Rachida* (Algeria, 2003).

Bouchareb, Rachid. *Indigènes* (Days of glory, Algeria, 2006).

———. *La voie de l'ennemi* (Two men in town, Algeria, 2014).

———. *Little Senegal* (Algeria, 2001).

———. *London River* (Algeria, 2009).

Djadjam, Mostefa. *Frontières* (Borders, Algeria, 2002).

Djahnine, Habiba. *Lettre à ma sœur* (Letter to my sister, Algeria, 2008).

El Fani, Nadia. *Bedwin Hacker* (Tunisia, 2002).

Ellerson, Beti. *Sisters of the Screen: African Women on Film* (U.S., 2002).

Ferroukhi, Ishmaïl. *Le grand voyage* (The long journey, Morocco, 2005).

Haroun, Mahamat-Saleh. *Un homme qui crie* (A screaming man, Chad, 2010).

Igbokwe, Chinua. *Generational Curse 1* (Nigeria, 2016).

Kassari, Yasmine. *L'enfant endormi* (The sleeping child, Morocco, 2004).

Kobhio, Bassek ba, and Didier Ouénangaré. *Le silence de la forêt* (The forest, Gabon / Central African Republic, 2003).

Lakhmari, Nourradine. *El kadia* (The affair, Morocco, 2006).

Mahlatsi, Teboho. *Yizo Yizo* (This is it!, South Africa, 1999–2001).

Man Alone. *American Igwe 1* (Nigeria, 2016).

Manso, Israel. *Chisom the Hustler* (Ghana, 2016).

Marrakchi, Leïla. *Marock* (Morocco, 2005).

Nejjar, Narjiss. *Les yeux secs* (Dry eyes, Morocco, 2002).

Sacchi, Franco. *This Is Nollywood* (Nigeria, 2015).

Sahraoui, Djamila. *Barakat!* (Enough!, Algeria, 2006).

Sissako, Abderrahmane. *Bamako* (Mauritania, 2006).

———. *Timbuktu* (Mauritania, 2015).

Taïa, Abdellah. *L'armée du salut* (Salvation army, Morocco, 2015).

Traoré, Moussa. *La pirogue* (The boat, Senegal, 2012).

INDEX

169

ABOUT THE AUTHOR

Valérie K. Orlando is a professor of French and Francophone literatures in the Department of French and Italian at the University of Maryland, College Park. She is the author of the following books: *The Algerian New Novel: The Poetics of a Modern Nation, 1950–1979* (2017), *Screening Morocco: Contemporary Film in a Changing Society* (2011), *Francophone Voices of the "New Morocco" in Film and Print: (Re)presenting a Society in Transition* (2009), *Of Suffocated Hearts and Tortured Souls: Seeking Subjecthood through Madness in Francophone Women's Writing of Africa and the Caribbean* (2003), and *Nomadic Voices of Exile: Feminine Identity in Francophone Literature of the Maghreb* (1999). She coedited with Sandra M. Cypess *Reimagining the Caribbean: Conversations among the Creole, English, French, and Spanish Caribbean* (2014). Additionally, she has written numerous articles on Francophone writing from the African diaspora, African cinema, and French literature and culture.

ABOUT THE AUTHOR